THE ART OF
VICTORIAN
CHILDHOOD

Richard O'Neill

A Compilation of Works from the

BRIDGEMAN ART LIBRARY

SMITHMARK

The Art of Victorian Childhood

This edition published in 1996 by SMITHMARK
Publishers, a division of U.S. Media Holdings, Inc.,
16 East 32nd Street, New York, NY 10016.
SMITHMARK books are available for bulk
purchase for sales promotion and premium use.
For details write or call the manager of special
sales, SMITHMARK Publishers, 16 East 32nd
Street, New York, NY 10016; (212) 532-6600
First published in Great Britain in 1996 by
Parragon Books Limited
Units 13-17, Avonbridge Industrial Estate
Atlantic Road, Avonmouth, Bristol BS11 9QD
United Kingdom

© Parragon Books Limited 1996

ISBN 0-7651-9802-9

Printed in Italy

Editors: Barbara Horn, Alex Stace, Alison Stace, Tucker Slingsby Ltd
 and Jennifer Warner

Designers: Robert Mathias • Pedro Prá-Lopez, Kingfisher Design Services

Typesetting/DTP: Frances Prá-Lopez, Kingfisher Design Services

Picture Research: Kathy Lockley

The publishers would like to thank Joanna Hartleyat the Bridgeman Art Library
for her invaluable help.

Victorian Childhood

It has been said that the Victorians invented childhood. The credit should more properly go to the Age of Reason, and especially to the French philosopher Jean Jacques Rousseau, whose *Émile, ou Traité de l'éducation* (1762) profoundly influenced intellectual attitudes to childhood. But in so far as the Victorian era of around 1830-1900 was the first in which the child was generally regarded as a distinct kind of being, rather than as an embryo adult, the claim is to some extent justified.

There was, however, a dichotomy in the Victorian attitude to children. On the one hand they were seen as innocents, to be idealized in art and literature: on the other, as potential savages in whom the 'old Adam' needed to be firmly repressed. The age that saw wide-ranging social reforms affecting both adults and children; such child-centred phenomena as the development of Christmas and the rise of a flourishing toy-making industry, saw also the most heavy-handed attempts to force children to conform to accepted social norms. To take examples from Dickens, the voice of his age if any writer was, it is the all-too-believable Gradgrind of *Hard Times* rather than the grotesque Squeers of *Nicholas Nickleby* who truly embodies the faults of Victorian attitudes to children.

The views of childhood in this book range from near sublime, such as those of Millais and Courbet, to those still famous, such as Landseer, Frith, and Greenaway, to the now forgotten. With a few exceptions, notably Faed and Herkomer, they reflect only one side of the Victorian viewpoint. Their children, whether seen in upper-

class drawing rooms or cottage kitchens, are rosy-cheeked, healthy and happy innocents; even Horsley's ragged crossing-sweeper (page 25) shows little sign of deprivation.

Are we to assume that these artists knew nothing of society's division into what Benjamin Disraeli, in *Sybil* (1846), described as '...the Privileged and the People... Two nations, between whom there is no contact and no sympathy'? Did they not know that in the earlier Victorian age children as young as five laboured a full day in field, factory or mine; that in the 1850s an estimated 500,000 children were immured in prison-like workhouses; that as late as 1890 William Booth found that one-tenth of Britain's population existed in the direst poverty? Did they not realize that most working-class children had no time to *be* children? The future Labour leader James Keir Hardie, born into a Scottish miner's family in 1856, described himself (and the many like him) as '...one of the unfortunate class who never knew what it was to be a child'.

Of course they knew these things, sometimes from personal experience. William Mulready's father was an unsuccessful maker of leather breeches; Frith's parents left domestic service to open a pub and went bust, and the artist himself claimed to have been educated at the original 'Dotheboys Hall'. But although caricaturists and illustrators like George Cruikshank and Gustave Doré produced truly horrifying scenes of the under-side of Victorian life, painters generally fought shy of such subjects. For a simple reason: there was little or no market for 'unpleasant' paintings.

In both style and subject matter, the 19th century genre painters whose art occupies the greater part of this book much resemble the Dutch genre artists of the 17th century, notably Adriaan van Ostade, David Teniers the Younger and Pieter de Hooch. The work of those Dutchmen generally avoids the low-life elements, the drunken, pissing and spewing peasants, that enliven

the paintings of earlier Netherlandish artists. And for the same reason as the Victorians eschewed undue realism: the rise of an affluent middle-class had created a market for pleasant, undemanding pictures to hang on living-room walls.

One may lament the lack of moral seriousness in much Victorian painting and mock the sentimentality that especially marks the era's portrayals of children. Yet one can hardly condemn an artist for preferring to make a living rather than starve in a garret. Millais painted 'cute' child portraits that he knew would sell hugely as colour prints; but he also produced such masterpieces as *The Blind Girl* (page 45). Myles Birket Foster (page 37) painted no masterpieces but his well-crafted pictures still give pleasure to many people.

▷ **Lending a Bite** c. 1815
William Mulready (1786-1863)

Oil on canvas

ALTHOUGH THIS PAINTING predates Victoria's reign, its style and subject matter are typical of its successors. Like many Victorian genre paintings, it owes much to Dutch genre works of the 17th century: Mulready acknowledged his main influence as that of Sir David Wilkie (1785-1841), the Scottish genre master whose style was modelled on van Ostade and the younger Teniers. Here, a lad with an apple (perhaps an apothecary's errand boy, from his apron and the alembic beside him)

fears that the bite he is 'lending' his friend will be over-generous. Behind the boys, a customer points out his chosen fruit to a pedlar; in the background, a girl munches her apple while a dog waits hopefully for her 'lendings'. The respective apprehension and rapaciousness of the boys are ably and amusingly rendered by Mulready, an Irish-born painter and illustrator whose lasting claim to fame is that in 1840 he designed the official envelope for the new Penny Post.

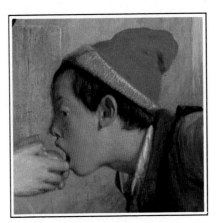

Detail

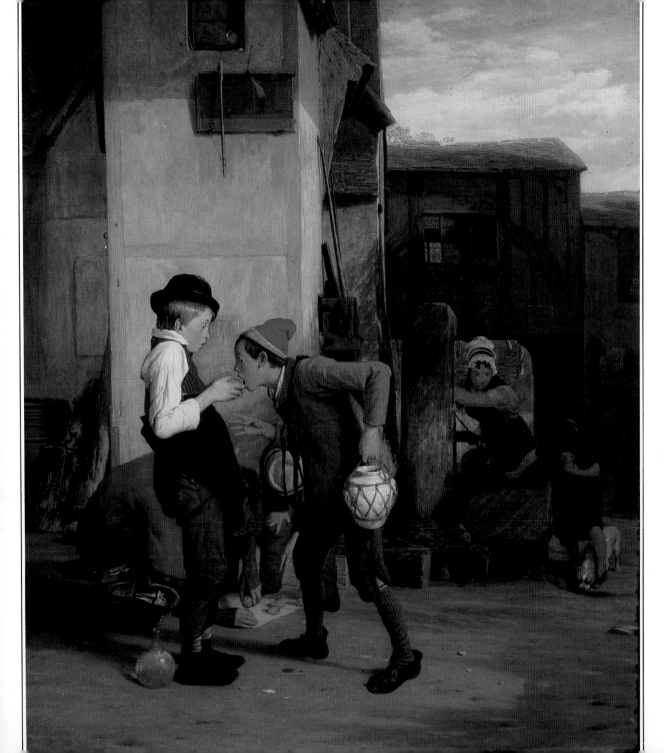

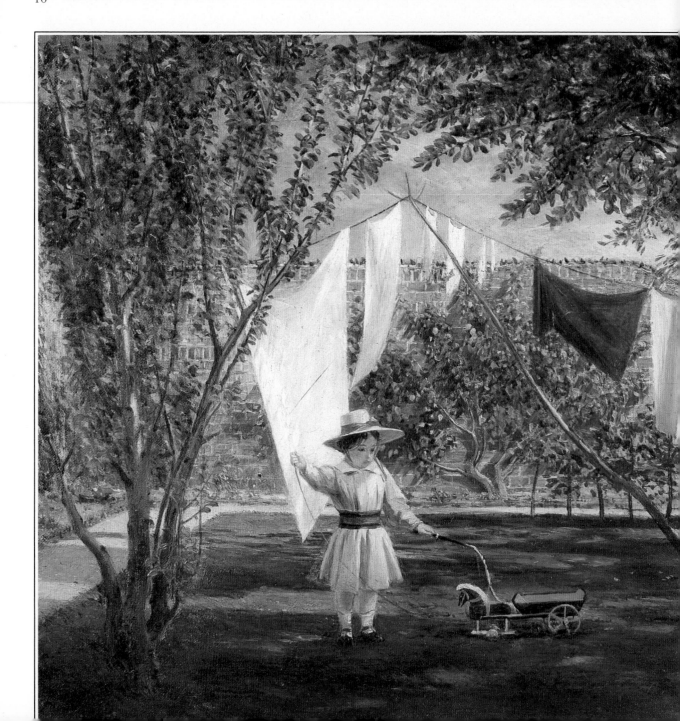

◁ **A Garden Scene** 1840
Charles Robert Leslie (1794-1859)

Oil on canvas

SHADED FROM THE SUN by a broad-brimmed straw hat, a child (George Dunlop Leslie, son of the artist) plays in a secluded garden. By the time of this painting, Victorian taste had replaced Georgian and Regency 'skeleton suits' for young boys (loose trousers buttoning onto a shirt) with dresses; by the 1870s, lads might not be 'breeched' until seven or eight years old. A line of washing adds a homely touch, but espaliered fruit trees hint at a well-to-do household. Indications of status may have been important to Leslie (born in London of American parents), whose youth was spent in comparative poverty in Philadelphia. Local merchants who admired his work helped him return to London in 1811 to study at the Royal Academy. By 1817 he had established a reputation with paintings of scenes from plays and novels and was an intimate friend of the poet Coleridge and the artists Constable and Landseer. His *Memoirs of the Life of John Constable* (1843), based on the painter's letters, remains a standard work.

▷ **Sickness and Health** 1843
Thomas Webster (1800-86)
Oil on canvas

THIS TYPICAL ANECDOTAL
painting was executed by one of
the masters of the genre.
Although a prize-winning
portraitist at the Royal Academy
Schools, London-born Webster
soon found where his real talent
lay and became most successful
with gently humorous pictures of
schoolboy pranks and rustic life,
most of which sold well as
engravings. Like a number of
other artists featured in this book,
he was a long-time member of the
'Cranbrook Circle', a group of
genre painters who lived and
worked (often together) in the
village of Cranbrook, Surrey. This
painting has all the basic
ingredients of popular Victorian
art: a sick child (but not too sick)
with a faithful dog; an anxious
mother; two pretty maids who
dance to cheer up the invalid, to
the music of an Italian organ-
grinder; a benevolent
grandmother figure; and –
Webster's forte – a 'Just William'
type of schoolboy who looks with
disdain on the girlish frolics.

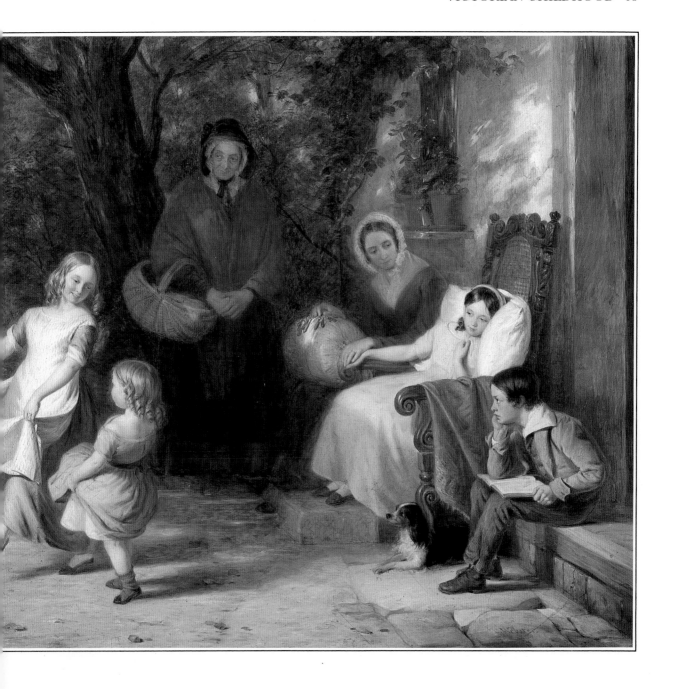

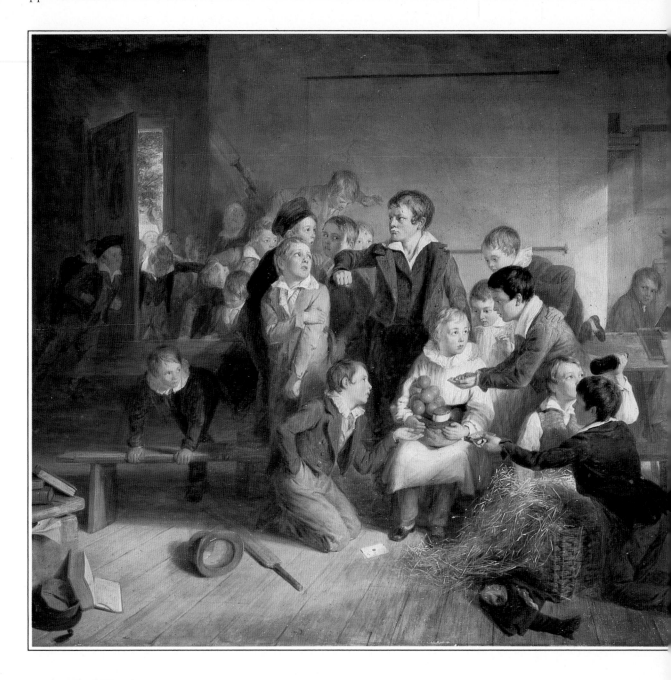

◁ **The Boy with Many Friends**
Thomas Webster

Oil on canvas

THE *DICTIONARY OF NATIONAL BIOGRAPHY* remarks: 'In the limited range of subjects which he made his own, Webster is unrivalled.' Certainly, there are few livelier representations of a Victorian school than this. The new boy, a fresh-faced innocent whose smock marks him as a country bumpkin, has arrived with a hamper, and is surrounded by 'friends' eager to beg or barter (one offers a handful of marbles) for a share of the goodies. It also looks as though the bully just behind him will demand a tribute once he has finished thumping his smaller victim. In the absence of the master, whose desk makes a perch for one miscreant, the class runs wild. A crowd storms the door; two boys try vainly to stem the flood, while another threatens mayhem with a cricket bat. Only the class 'swot' and an older, fashionably-dressed youth in an attitude of weary resignation remain aloof.

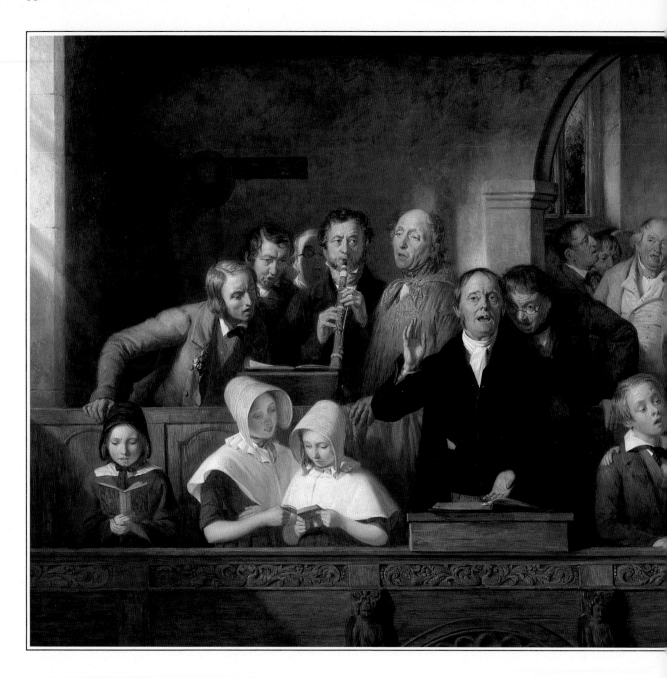

◁ **The Village Choir** 1847
Thomas Webster

Oil on Canvas

IF THIS PAINTING, Webster's best-known work, did not antedate the novel by some twenty-five years, it could be an illustration for *Under the Greenwood Tree*, in which Thomas Hardy describes just such a choir and church band remembered from his Dorset boyhood. As Hardy tells us, by around the time of this painting the rustic musicians shown were being supplanted by the recently-developed harmonium or other 'cabinet organs'. Webster both looks back to the 'conversation pieces' of such 18th century painters as Zoffany and anticipates later Victorian 'problem pictures'. We ask ourselves just what the bespectacled fellow is whispering to the choirmaster. Why does the 'cellist glance so suspiciously towards the two angelic choirboys? They look no more capable of mischief than the girl singers, demure in their straw poke bonnets and spotless white tippets. The clarinettist certainly has something on his mind: is the elderly labourer in the smock singing flat?

▷ The First Leap
Sir Edwin Henry Landseer (1802-73)

Oil on canvas

THE YOUNG RIDER (whose peaked cap probably dates the picture to before about 1850, when such headgear was fashionable for boys of all classes) sets his pony at a fallen tree and over they go, scattering a family of goats. Landseer, most famous of Victorian animal painters and a favourite of the pet-loving Queen, who knighted him in 1851, learned his craft young. His father, the engraver John Landseer (1769-1852), had him sketching beasts from life in his infancy: animal drawings he made at the age of five are now in London's Victoria and Albert Museum and by the age of thirteen he was exhibiting at the Royal Academy. This minor work is free of Landseer's two most notable faults: excessive anthropomorphism, as in his 'nearly human' dogs, and, if we accept that the boy's whip is wielded out of sheer exuberance, a streak of cruelty. The rider may well be the child of one of Landseer's many wealthy patrons.

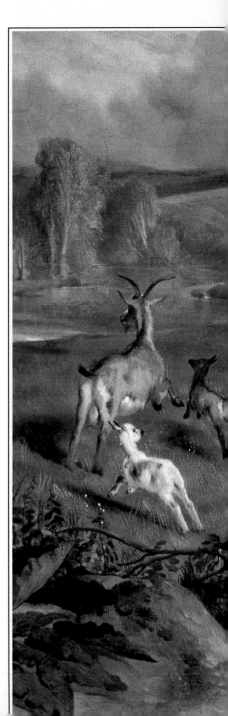

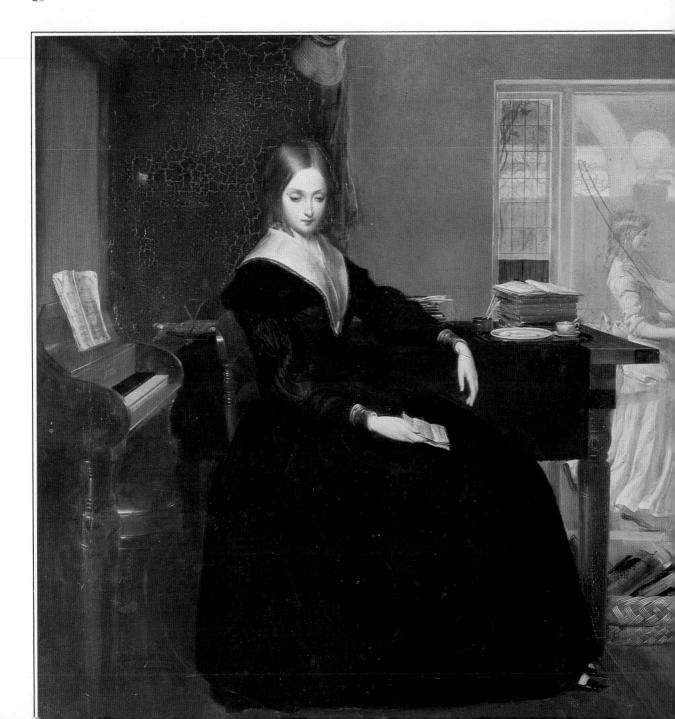

◁ **The Governess** 1844
Richard Redgrave (1804-88)

Oil on canvas

REDGRAVE'S BEST-KNOWN
painting was first exhibited as *The
Poor Teacher*. Certainly, the drab
room with its bare floor and the
playground's spiked railings
suggest that the setting is a school
rather than a private home. He
originally painted only the teacher
herself: hardly more than school
age, dressed in mourning black,
sorrowing over a letter, with *'Home,
Sweet Home'* (popular since 1823)
on the piano at her back. She is
one of a multitude of girls of good
family whom misfortune has
reduced to drudgery. The
contrasting figures of the pretty
pupils in their gay dresses, two
skipping, the other daydreaming
over her task, were added at the
request of a wealthy collector.
Redgrave's output was limited by
his involvement in art education.
He helped establish the
Government School of Design,
first state-funded art school, in
1847, and from 1857 was
Inspector-General of Art Schools.
With his brother Samuel (1802-
76), he wrote *A Century of Painters of
the English School* (1866), still a
valuable reference work.

▷ **'They have seen better days'**
Jacob Thompson (1806-79)

Oil on Canvas

WE ARE GIVEN CLUES to the meaning of this anecdotal picture. The house is too grand for a cottage; too rustic for a mansion. It must be a farmhouse, once prosperous, now in decay. The family group consists of mother, grandmother, children and faithful sheep-dog: we deduce that the father has died (in his prime, for the children are still young) and his family faces hard times. A more prosperous neighbour (whose long, full skirt, large shawl, and bonnet with flared brim appear to date the picture to the 1850s) has perhaps come to offer aid; perhaps (since it is her own child who appears to be receiving a gift from the farmer's daughter) to teach her daughter a moral lesson by showing her how folk bear up under adversity. The subject must have appealed to Thompson, whose father, a linen manufacturer in Penrith, Cumberland, was ruined by the war of 1812. The would-be artist was apprenticed to a housepainter but was rescued by the patronage of a local nobleman.

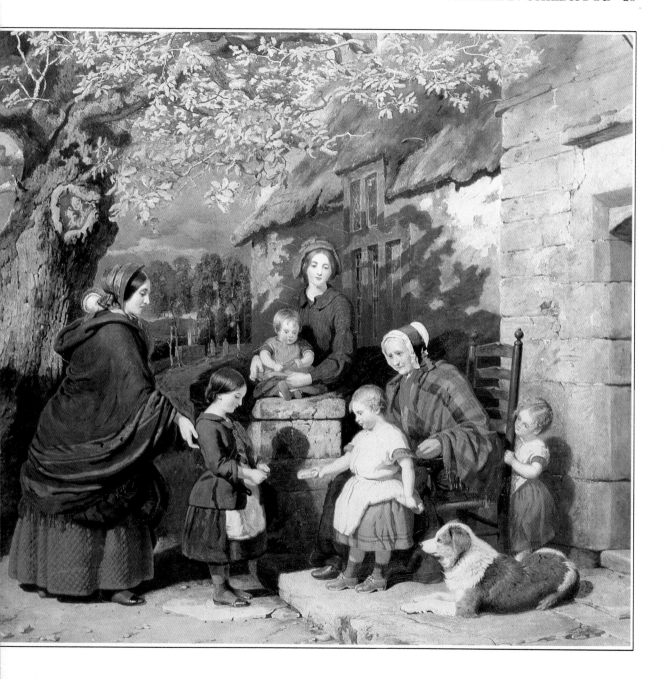

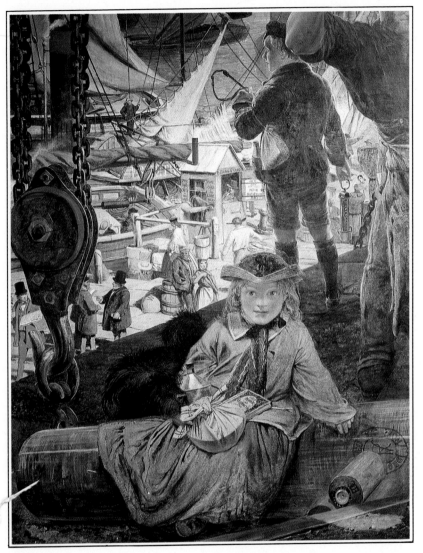

◁ **Industry of the Tyne: Iron and Coal (detail)** c. 1850
William Bell Scott (1811-90)

Oil on canvas

ALTHOUGH VICTORIAN BRITAIN was the 'workshop of the world', paintings of heavy industry are rare. Edinburgh-born Scott was one of the few to tackle the subject, specializing in scenes of Northumbrian history and of the booming industries of Tyneside. Scott was a poet of repute, a friend of Swinburne, and his approach to industrial subjects was one of romantic optimism. There are no 'dark, satanic mills' here. At the bustling quayside, a worker's little daughter, glowing with health and respectably clad, rests on a massive iron ingot, holding her father's dinner pail (which attracts the attention of the 'faithful friend') and tea flask. Behind her, a sturdy lad holding a miner's safety lamp waits with his father's 'snap'. In the girl's lap lies *The First Book of Arithmetic*: prosperity stemming from industry is opening the way to education and advancement for these craftsmen's children.

▷ The Crossing Sweeper
John Callcott Horsley (1817-1903)

Oil on canvas

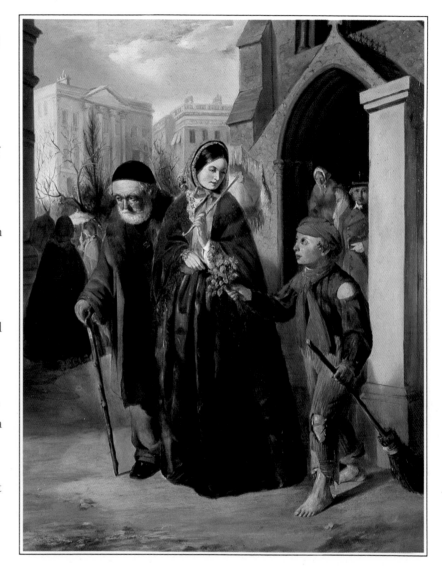

IN CONTRAST TO the well-dressed children portrayed by Scott (page 24), Horsley's crossing sweeper is barefoot and ragged. This child of the streets, living on the tips given by pedestrians for clearing mud and horse-dung from pavements and street crossings, would in reality have appeared far less clean and healthy than the artist's model. The dress of the young lady to whom he offers a nosegay may date the painting to around 1855 – just about the time that Charles Dickens described the real life of a crossing sweeper in his tragic portrait of 'Jo' in *Bleak House*. Horsley, with Webster (pages 12-17) and others a member of the 'Cranbrook Circle' of genre painters, was no realist: in 1885 he would lead opposition to the use of naked models in life classes, 'a practice fit only for Paris'! His major distinction is that in 1843 he designed Britain's first Christmas cards (showing a family enjoying a festive feast), sent by the arts' administrator Sir Henry Cole.

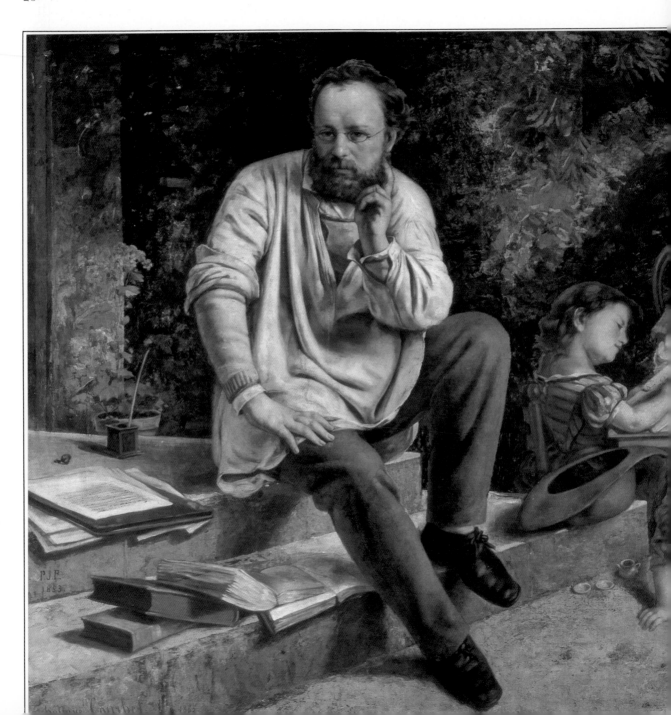

◁ **Pierre Joseph Proudhon and his Children in 1853** 1865
Gustave Courbet (1819-77)

Oil on canvas

ONE RADICAL PORTRAYED by another: the anarchist philosopher Proudhon (who famously declared: 'Property is Theft') is shown in 'thinker's' pose by a close friend and follower, the great French Realist painter Courbet. Both men suffered imprisonment and exile for their beliefs: Proudhon for savage attacks on the French government; Courbet for his violent participation in the Paris Commune of 1871-72. This work, painted in the year of Proudhon's death, not long after his collaboration with Courbet on a book *On Art and its Social Significance* (1863), shows the great man in happier times, with his two young daughters. As befits the offspring of a libertarian and hater of bourgeois convention, the little girls wear loose, comfortable clothes and have short, simple hairstyles. While the younger is intent on her fantasy play with a miniature tea service, the elder smiles as she learns her letters: another thinker is in the making.

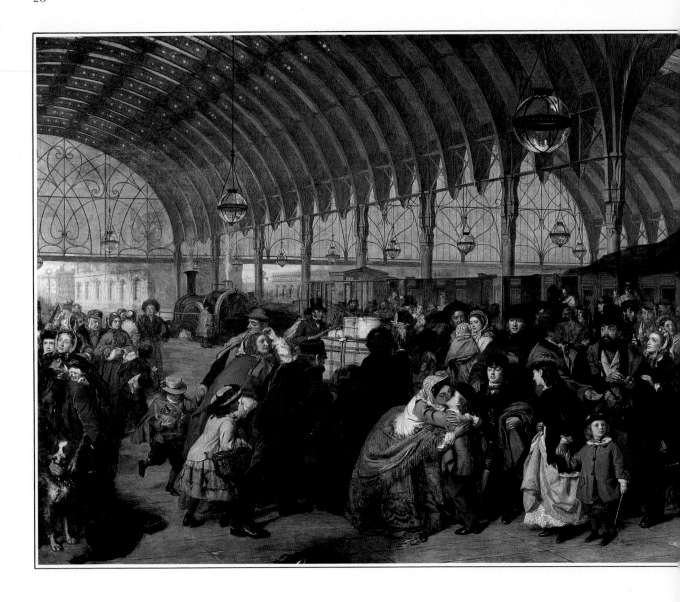

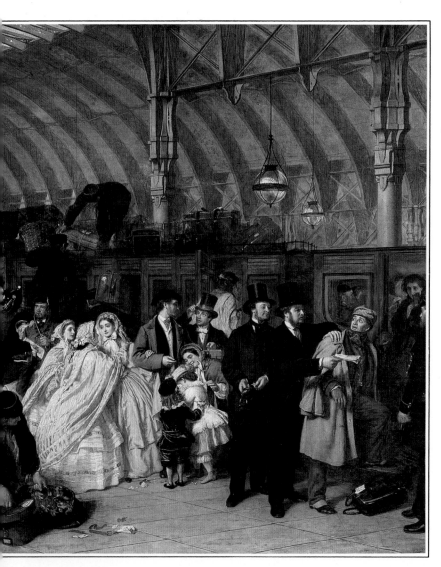

◁ **The Railway Station** 1862
William Powell Frith (1819-1909)

Oil on canvas

ALTHOUGH THE REVERED CRITIC John Ruskin hailed Frith's huge anecdotal canvases as 'the art of the future', others condemned his vulgarity. Frith, noting that rails were put up at the Royal Academy to protect his works from admiring crowds, laughed all the way to the bank: he was said to be the richest artist of his era. His truly photographic realism (he employed a photographer to record scenes at Paddington Station while 'building' this picture) makes him a social historians' delight. We read the painting like a novel. Concentrating on child characters, we move from the scampering latecomers on the left to a fond mother seeing her boy off to school with a kiss. Nearby a little chap in knickerbockers holds a whip to spin a top. There are children dressed as fashion plates farther right: a ringleted boy in a velvet suit; a girl whose short dress, revealing the legs of frilled pantalettes, apes the fashionable crinoline. At the centre of the bustle stands Frith himself: he is the bearded man arguing with a cabbie over his fare.

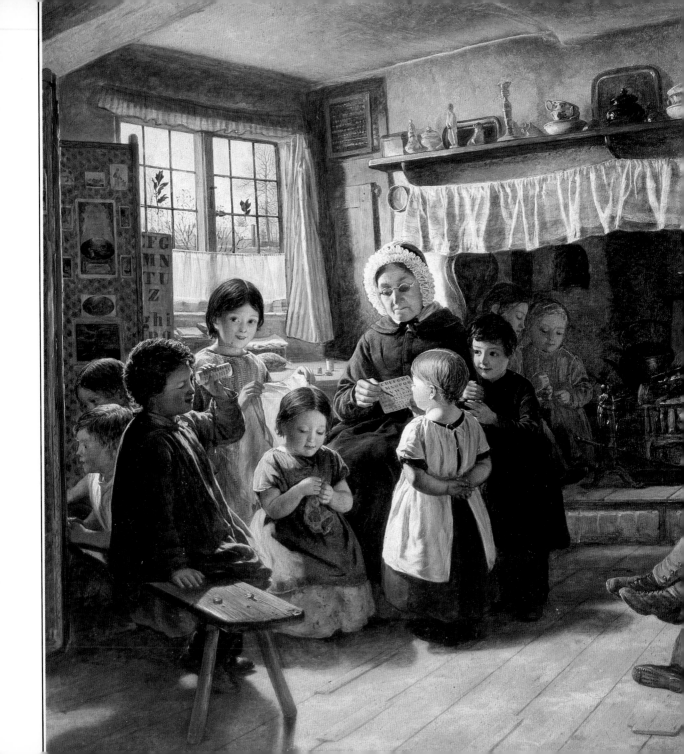

◁ **The School Room** 1856
Alfred Rankley (1819-72)

Oil on canvas

COMFORTABLE SENTIMENT and careful finish brought success to many Victorian artists, among them Rankley, a regular exhibitor at the Royal Academy from 1841. Finding few to praise his early works, high-flown literary and historical scenes, he turned to genre. Here he shows a dame school, so called because they were run by elderly women who taught the rudiments of the 'three Rs' in their own homes. A benevolent granny holds a class in her sparsely-furnished but well-scrubbed parlour. The children too are well-scrubbed: rosy-cheeked and charming in their clean, unpatched pinafores and smocks (note the gaiters and stout boots, typical of the agricultural worker, of the lad on the bench). At this time, only working-class children were taught in mixed-sex classes – if they received any education at all. The Factory Act of 1833 decreed that all children should have two hours' instruction each day but until 1844, when juvenile working hours were shortened, few working-class children over the age of six or seven had time for schooling.

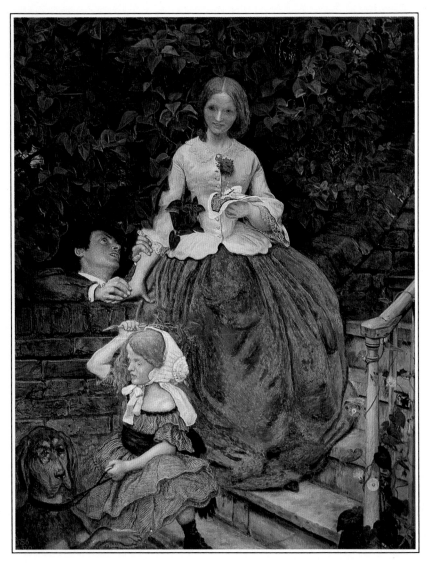

◁ **Stages of Cruelty** c. 1855
Ford Madox Brown (1821-93)

Oil on canvas

BEGUN SOON AFTER completion of
one of his best-known works, *The
Last of England* (1855), this shows a
major artist in lighter mood.
Brown borrows title and idea from
Hogarth: the wilful unkindness of
the little girl who is about to
chastise her bloodhound
anticipates her big sister's teasing
indifference to a despairing suitor.
If we regret the lack of moral
seriousness that dignifies *The Last
of England* and *Work*, we should
remember Brown's own mistrust
of artists 'who never painted from
love of the mere look of things'
and his assertion that 'pictures
must be judged first as pictures'.
The meticulous craftsmanship and
brilliant colouring that Brown
originally learned from the
Nazarenes, German painters
working in Rome, and helped pass
on to the Pre-Raphaelite
Brotherhood, whom he both
influenced and was influenced by,
make this a thoroughly satisfying
painting. Neither widely popular
nor well rewarded in his lifetime,
Brown is now far more highly
regarded than such successful
contemporaries as Foster (page 37)
or Webster.

▷ **The Phrenologist**
William Henry Knight (1823-63)

Oil on canvas

VICTORIANS WERE AS SUBJECT TO health and life-style crazes as we are today. One was phrenology, pioneered by Franz Gall (1758-1828), an Austrian physician who claimed that character and talents could be deduced from 'reading the bumps' on a person's skull. He theorized that different areas of the brain controlled particular character aspects: generosity, spirituality, combativeness, mechanical skills, and so on. Bumps and ridges on the skull showed that the parts of the brain they covered were most in use, so their functions were likely to be dominant. After Queen Victoria called in a bump-reader to assess her children, phrenology became wildly fashionable in Britain. Knight shows a 'professor' with his tools: a human skull and a china head diagrammed with Gall's brain-plan. While mother and sister await his verdict (which we may be sure will be encouraging), he feels the skull of a smirking, lace-collared moppet who cuddles the inevitable dog.

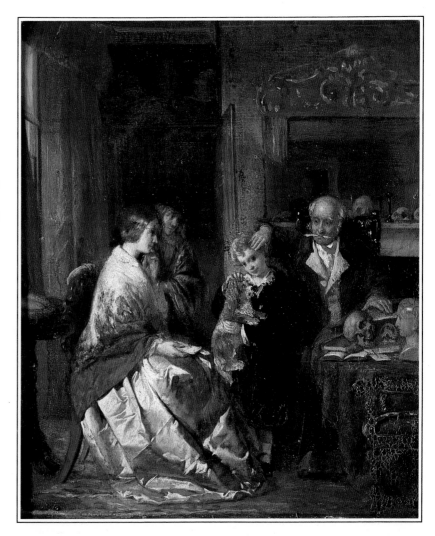

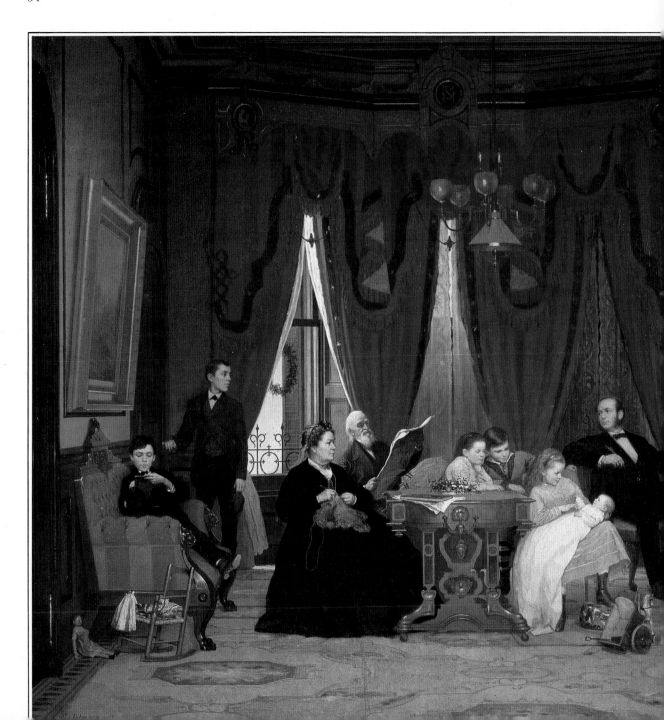

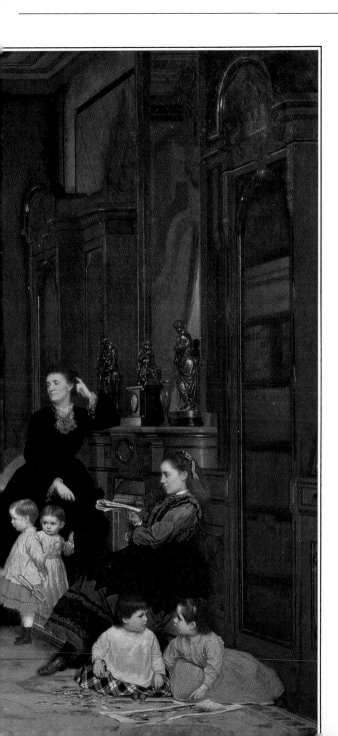

◁ **The Hatch Family** 1871
(Jonathan) Eastman Johnson
(1824-1906)

Oil on canvas

THREE GENERATIONS of an
American family, from a bearded
patriarch to his newest grandchild,
are seen in a plush-curtained
living room. Will Grandpa's
reading be disturbed when the
small boy (still in a dress) near the
fireplace toots his toy trombone?
The toys are familiar: the boy and
girl in the right foreground work a
jigsaw puzzle; a wheeled horse-
and-cart lies abandoned; a doll
waits to be dressed on the extreme
left. The eleven children range
from the babe in arms to the
elegantly-gowned girl on the right,
who must be almost ready to put
up her hair in a style marking her
admission to the grown-up world.
Do they all belong to the soberly-
dressed matron who leans on the
chimney-piece? We may assume
so, for in the Victorian era, in
Britain and America alike, families
of ten or more were not
uncommon. Johnson, a New
Yorker, is best known for paintings
of another kind: he specialized in
scenes of farming and frontier life,
and studies of Native Americans
and African Americans.

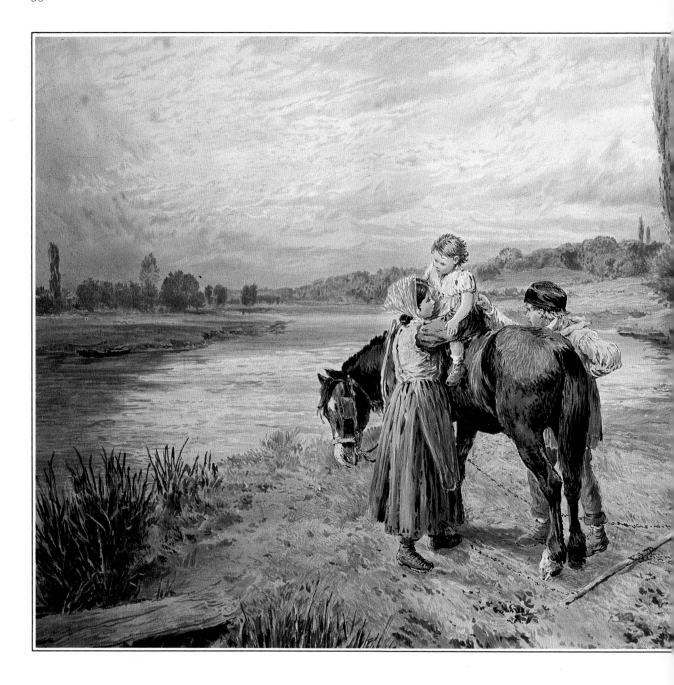

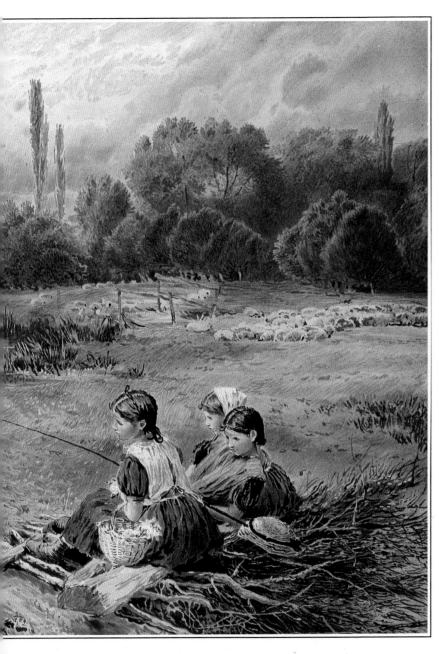

◁ **The Ride on the Pony**
Myles Birket Foster 1825-99

Watercolour

NOT ONLY MUST THE PONY provide baby with its first ride, it is also expected to pull an improvised travois (Native American vehicle) of brushwood on which three girls recline. The pony, however, is the only being we need to feel sorry for: the cottagers' children are all healthy, adequately clad, and obviously enjoying a life of leisure. Such idealized rural scenes, most set in the Surrey countryside around his home, made a fortune for Foster, who had his finger firmly on the popular pulse. He now remains a favourite only with producers (and buyers) of greetings cards. His many watercolours are certainly sentimental and untrue to life, but his technique (as might be expected of an artist who made his name as a wood engraver before turning to paint around 1860) is impeccable and the delicacy of his handling most appealing. His close friends Edward Burne-Jones and William Morris would not have wasted time on a mere hack; nor would the realist Sickert have praised Foster's 'charming little girls' without good reason.

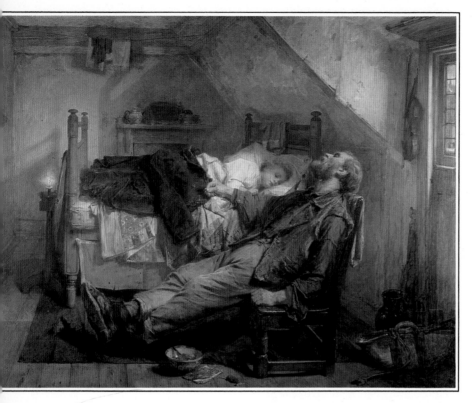

◁ **Worn out**
Thomas Faed (1826-1900)

Oil on canvas

TOO WORN OUT even to unlace his boots; too weary even to finish his supper, which a mouse creeps out to nibble; a man sprawls by the bedside of his sleeping child. His last action before giving way to fatigue has been to add his jacket to her threadbare coverings. (Do we assume the child is sick? Perhaps she too is 'worn out'.) From the father's work-grimed clothes and the tool-bag in the corner we see that he is industrious; from the fiddle on the wall, we deduce that he has some appreciation of finer things. The painting is typical of Faed, born in Kircudbrightshire, who made his name with *The Mitherless Bairn* (1855). An excellent draughtsman, more realistic than many of his contemporaries and thus able to render scenes of humble life with real drama rather than false and patronising sentiment, he remained a leading painter of Scottish genre subjects until blindness ended his career in 1892. His works sold well as engravings, some executed by his brother John Faed (1819-1902), a noted miniature painter.

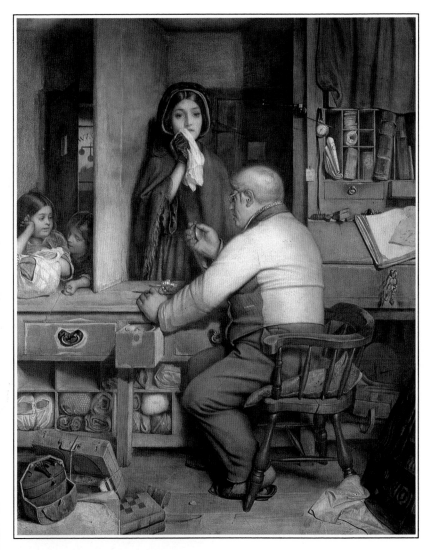

◁ **At the Pawnbroker's**
Thomas Reynolds Lamont
(1826-98)

Oil on canvas

ALTHOUGH THE YOUNG WIDOW is reduced to tears by the necessity of pawning her late husband's watch, the little girls with their bundle treat the transaction as a routine task. So it was for many working-class children: taking pledges to 'the working man's banker' was their job, lest parental pride be damaged by nosy neighbours recording their visits to 'Uncle'. As late as the 1930s, in depressed areas, it was common practice to pawn the family's best clothes on a Monday, redeeming them on pay-day for a Sunday outing. Victorian moralistic literature delights in tales of craftsmen whose road to ruin begins when they 'pop' their tools to finance a weekend booze-up and are unable to redeem them for work on Monday. By the turn of the century there were more than 5,000 licensed pawnbrokers' premises in England. It was estimated that 75 percent of their trade was in poor folks' 'napery and drapery', pawned for periods of one week or less.

▷ **Playing at Doctors** 1863
Frederick Daniel Hardy (1826-1911)

Oil on canvas

'DOCTORS AND NURSES' is one of the oldest games played by children, as popular in the Victorian age as it was in ancient Egypt and as it remains today. Here, the extremely healthy 'patient' giggles as the 'doctor' solemnly takes her pulse. Two would-be apothecaries use a pestle and mortar to make pills of bread crumbs (and a fine mess on the floor), while the youngest paramedics raid the medicine cupboard for more potent remedies. Perhaps it is just as well that the game is about to be brought to an end: the toddler has just spotted mother approaching, with granny (whose infirmity has both suggested the game and supplied its materials, including the night-cap that crowns the patient) on her arm. The greater part of Hardy's output consisted of gently humorous domestic scenes like this: embodying such features of earlier Dutch genre painting as the convex mirror above the chimneypiece and the carefully-detailed floor covering.

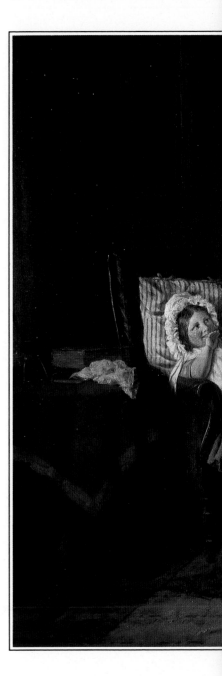

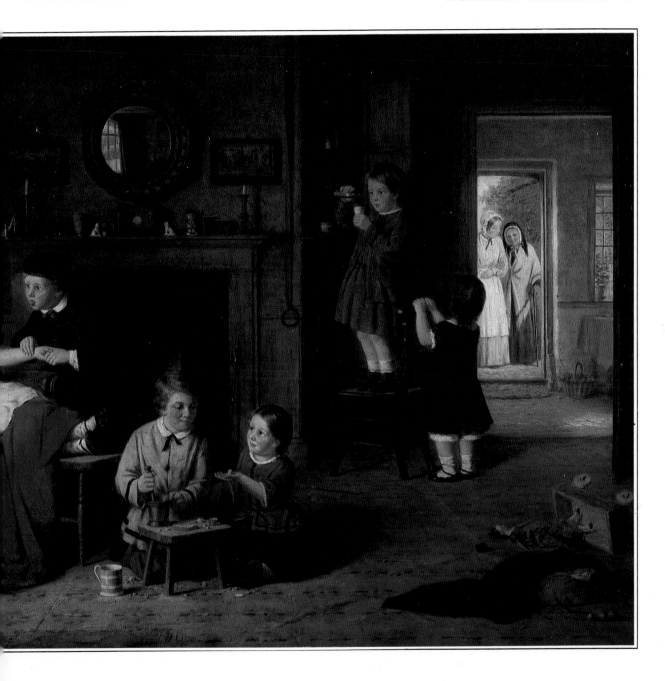

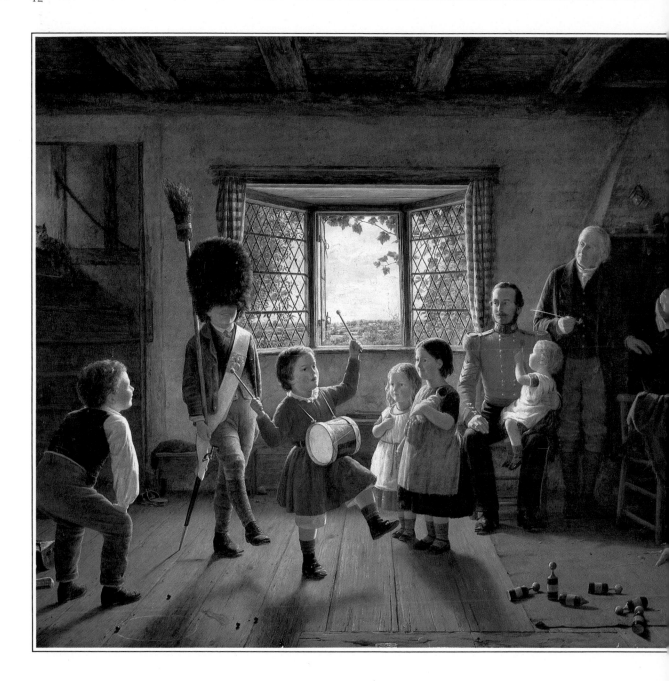

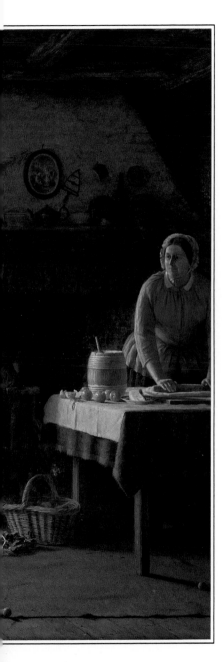

◁ **The Volunteers**
Frederick Daniel Hardy

Oil on canvas

HARDY WAS A COUSIN OF Thomas Webster (pages 12-17) and, like him, specialized in scenes of humble but well-scrubbed domestic life. Both Hardy and his brother George (1822-1909), another genre painter, were members of the long-established (c. 1855-95) 'Cranbrook Circle' and sometimes worked alongside Webster, Horsley (page 25) and O'Neill (page 49) at the Old Studio there. Here Hardy adds a patriotic sub-text to a typically lively composition. Father, a sergeant in Her Majesty's Guards, and grandpa look on with pride as the big boy of the family, resplendent in bearskin, crossbelt and bayonet, shoulders his broomstick musket and steps out smartly to the beat of his younger brother's drum. The little sisters (one suggesting the role of a woman who clutches her baby as she sees her man march away) watch admiringly. The skittles in the right foreground lie toppled like Britannia's enemies in the many colonial wars of Victoria's reign. Father's full-dress finery suggests that he is a recruiting sergeant, drumming up volunteers for just such a campaign.

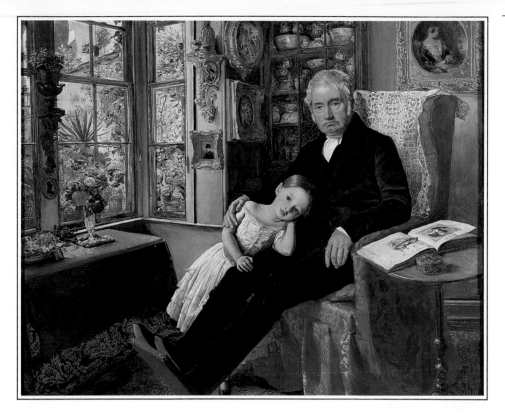

△ **James Wyatt and His Granddaughter** 1849
Sir John Everett Millais (1826-96)

Oil on canvas

THE BRILLIANT COLOURING and sharp-edged detail that typify the paintings of the Pre-Raphaelite Brotherhood are evident in this work, painted by Millais soon after the Brotherhood's formation in 1848. As the *objets d'art* that crowd the room suggest, James Wyatt was an art dealer and patron, the purchaser of several of Millais' early works. Although Wyatt dominates the composition, his little granddaughter shows us that the young Millais was already a master of child portraiture. Her physical fragility and pensive expression contrast touchingly with her burly grandfather's 'no nonsense' air. Apart from the low neckline, short sleeves and calf-length skirt that mark it as a child's garment, her muslin day dress much resembles those worn by women of the period. At the time of this painting Millais was already working on his *Christ in the House of His Parents*, which would provoke Charles Dickens's famous denunciation of the child Jesus as 'a hideous, wry-necked, blubbering, red-headed boy'.

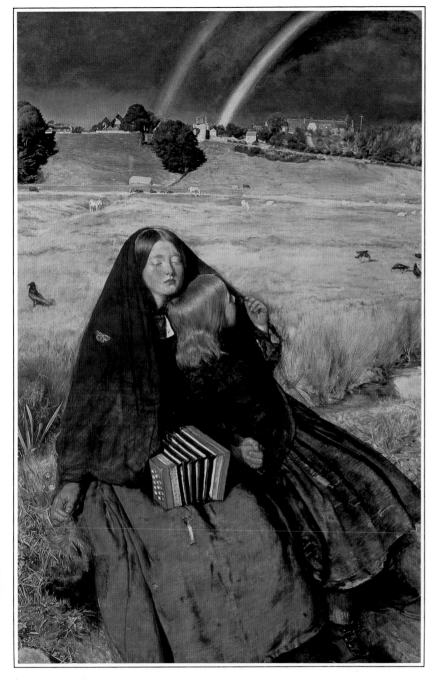

◁ **The Blind Girl** 1856
Sir John Everett Millais

Oil on canvas

IT IS ARGUABLE that Millais, still a young man, reached the height of his achievement in this painting and *Autumn Leaves* of the same year. In 1855 he had married Euphemia (Effie) Gray, whose marriage to John Ruskin had ended scandalously in annulment in 1854. Millais was overjoyed by the birth of their first child in 1856, yet melancholy informs both masterpieces of that year. The blind girl, forced to earn a living as an itinerant entertainer, branded by a crudely-lettered notice around her neck, rests by the wayside near a village. The fragile loveliness of the harebells among which she sits, the brilliance of the butterfly on her shawl, the sparkling beauty of the landscape after a shower, the miracle of the twin rainbows: all are denied her. Yet her rapt expression suggests that she is somehow experiencing the glory she cannot see. Her sighted companion clasps the blind girl's hand and shelters beneath her shawl: does she do so simply to escape the last drops of the shower, or to obscure her own view in an attempt to share the tragedy of sightlessness?

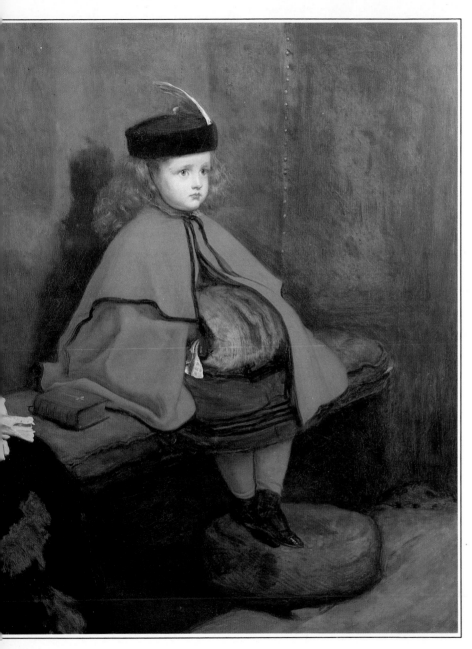

◁ **My First Sermon**
Sir John Everett Millais

Oil on canvas

SOLEMNLY ATTENTIVE, but perhaps fighting boredom, a little girl endures a lengthy Victorian sermon. She sits in semi-isolation in the corner of her family's box-pew; a partitioned enclosure that ensures its occupants privacy from all eyes save those of God and the preacher in the pulpit. As in many of Millais' child paintings, the model is one of his eight children by Effie. The work dates from between 1860 and 1870, when about 60 per cent of Britain's people were said to be regular worshippers. Many children were forbidden toys on the Sabbath and might read only the Bible – but perhaps Millais was a less strict paterfamilias. His little daughter wears her Sunday best: her full-skirted dress, trimmed with three rows of silk ribbon, is held out by starched petticoats to reflect the crinoline style. No doubt she is proud of her jaunty, plumed hat and bright red cape and stockings – while the muff is probably a necessity in the bleak church.

▷ **Bubbles** 1886
Sir John Everett Millais

Oil on canvas

PERHAPS THE BEST KNOWN, but far
from the best of Millais' works,
Bubbles illustrates both the strengths
and weaknesses of one of the
greatest painters of the Victorian
era. His immense talent is still
evident in the spontaneity of the
handling and the succulent
colouring, but the picture lacks any
purpose other than to please. The
artist himself was not pleased when
the soap-manufacturing firm of
Pears purchased the work, added a
bar of their product, and used it as
an advertisement. No doubt he
was comforted by the fact that he
was now earning up to £40,000 a
year from his art, largely from
fashionable portraits and from
prints and engravings of such
saccharine child pictures as *Cherry
Ripe* (1879), of which more than
500,000 colour reproductions were
sold, and by the baronetcy
awarded to him in 1885. The
model for *Bubbles* was his grandson
Willie, who in later life had a hard
time living down the distinction on
his way to becoming Admiral Sir
William James, RN.

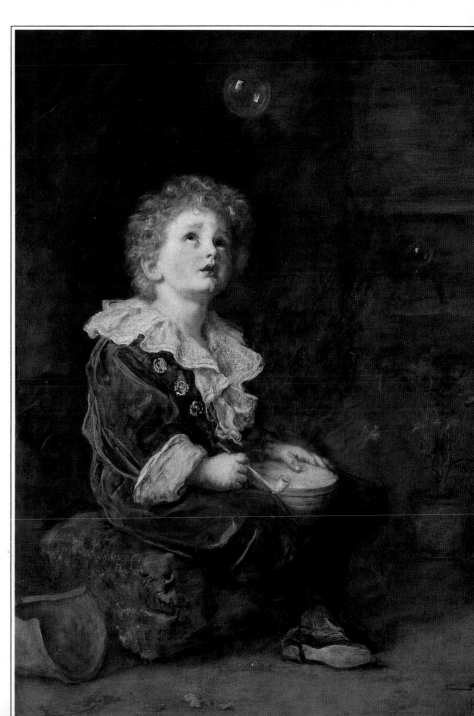

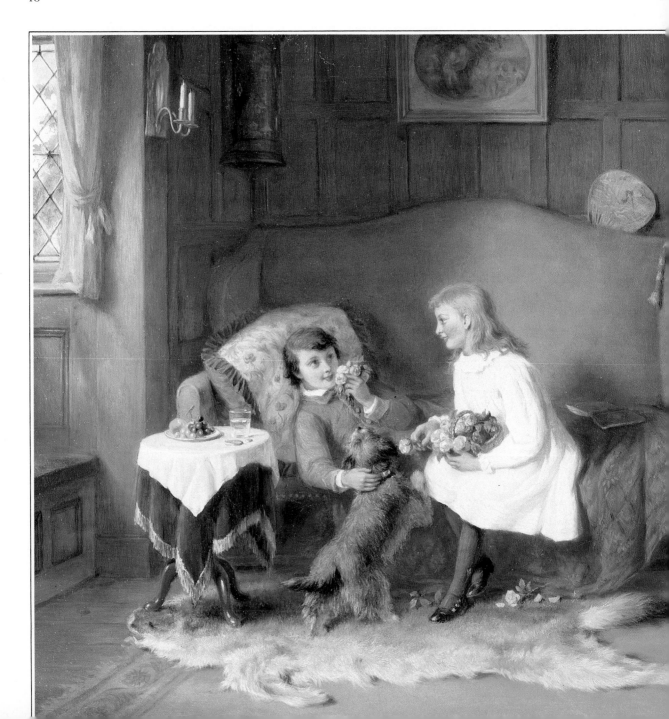

◁ **Feeling Much Better** 1901
George Bernard O'Neill (1828-1917)

Oil on canvas

SENTIMENTALITY IN THE WORK of a great painter, such as Millais, may be lamentable but remains bearable. When practised by a lesser artist, like O'Neill, it topples into bathos. Yet public taste ensured that the Dublin-born genre painter had a long and successful career, turning out hundreds of sentimental genre pictures of which this one, dating from the very end of Victoria's reign, is typical. The fresh-faced invalid gazes with adoration at his ravishing playmate, the damask hue on her cheek outshining that on the blossoms (to adopt a suitably high-Victorian turn of phrase!), who has brought him a tribute of roses. The faithful (the adjective, like the pictorial cliché, seems inescapable) dog that has, no doubt, watched beside his sick-bed is overjoyed to see his master's turn for the better. There is a mildly romantic subtext: will the young convalescent resent having his *tête-à-tête* with a pretty comforter disturbed by the lad who approaches with yet another gift of flowers?

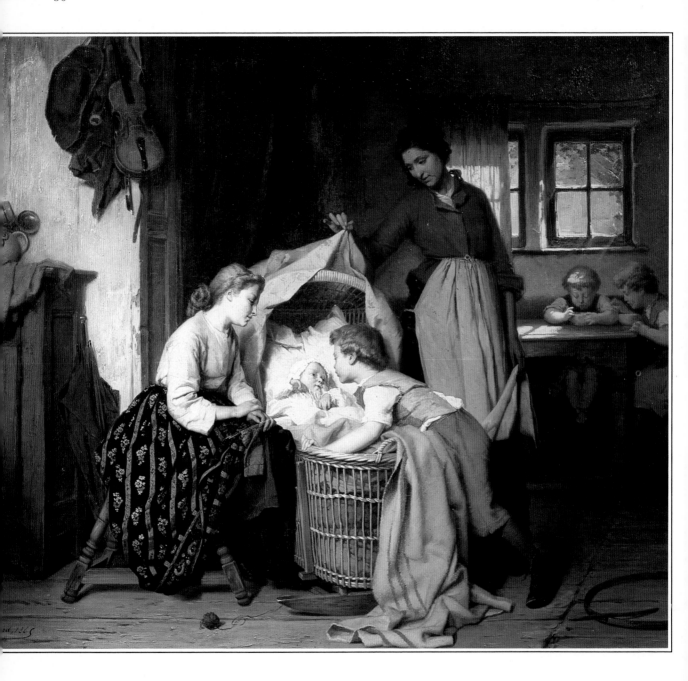

◁ **The Newborn Child** 1885
Theodore Gerard (1829-95)

Oil on canvas

A JOYFUL OCCASION in a working-class family is pleasingly captured by a Dutch-style genre painter. An older brother lays aside his hoop and stick to join mother and big sister (who momentarily forgets her knitting of a tiny garment) in admiring the family's newest member. His younger siblings remain intent on their porridge. The fiddle on the wall – a symbol employed in the same way by Faed (page 38) – tells us that the absent father, while too poor to afford a covering for the floor, has at least a smattering of culture. The mother's expression is thoughtful: what will this child grow up to be? Or is it: will this child grow up? Although general death rates fell as the Victorian age progressed, infant mortality rates remained high. In the late 1870s, Liverpool had a general death rate of 35 per 1,000, but an infant mortality rate of 269 per 1,000. The poor were, of course, most likely to lose their babies: infant mortality in London's East End ran at some three times the rate of that in the prosperous suburb of Hampstead.

▷ **As the twig is bent, so is the tree inclined**
James Hayllar (1829-1920)

Oil on canvas

A LITTLE GIRL (who seems more intent on charming the spectator than communing with her Maker) learns to pray by the side of her venerable grandfather. The old man wears the smock of an agricultural labourer, an allusion, which many Victorian viewers would no doubt have recognized, to the source of Hayllar's inspiration. This was *John Ploughman's Talk* (1869), a collection of simply-worded moral lectures by the charismatic Baptist preacher Charles Haddon Spurgeon (1834-92). Each essay was introduced by a popular proverb or saying: 'Much cry and little wool, as the man said when he sheared the sow', on boasting; 'There is a hole under his nose and his money runs into it', on intemperance, and so on. Although now little known, Hayllar had what may be a unique distinction. He was the father of four daughters, all of whom became painters of some reputation – notably the flower painter Kate Hayllar (exhibited 1883-1900) – and on one occasion the work of all five Hayllars was exhibited together at the Royal Academy.

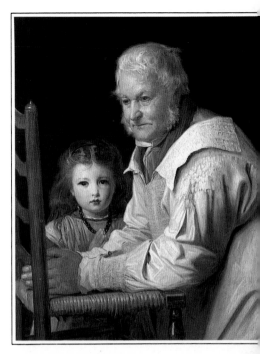

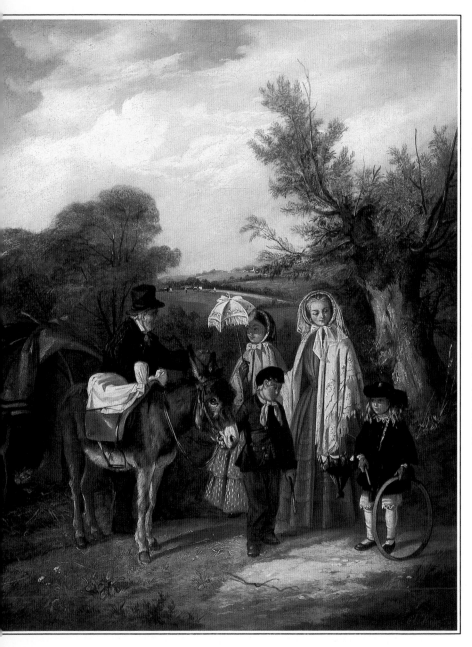

◁ **Wayside Tinker** 1859
Charles Hunt (1829-1900)

Oil on canvas

WHILE THE TINKER ATTEMPTS to interest the ladies in his wares, two very different boys eye each other with wary grins. Perhaps the son of the gentry, still in the girlish dress of childhood, envies the tinker's lad his corduroys and stout boots; maybe the tinker's boy wishes he could wear velvet and play hoop-and-stick rather than tending to dad's donkey. The smaller boy's knee-length skirts, revealing the legs of broderie anglaise drawers, are in the style fashionable for children of the well-to-do from the 1840s onward. The ladies wear the full skirts of the same period: although the painting is dated 1859, we must assume that the crinoline, fashionable from 1856, has not yet reached their country retreat.

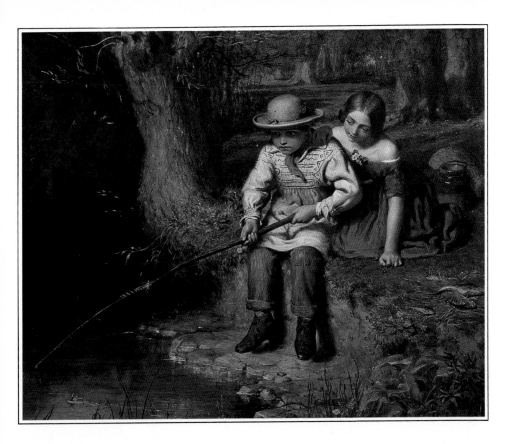

△ **Another Bite** 1850
George Smith (1829-1901)

Oil on canvas

DESPERATELY TRYING to
concentrate on his float in the
hope of adding to his haul of
perch, the young angler in this
picture is all too aware of the soft
hand on his shoulder. An added
element in the rustic idyll is that
the lad's smock-frock and
corduroys mark him as one of the
labouring classes; the girl's day-
dress and carefully-combed hair
suggest a higher social station.
Smith assisted in the painting of
frescoes in the newly-built Palace
of Westminster and exhibited
regularly at the Royal Academy
from 1847 until his death, by
which time his moderately realistic
(by the standards of the time)
genre studies had long been
overtaken in popularity by the
more idealized scenes of painters
like Foster (page 37).

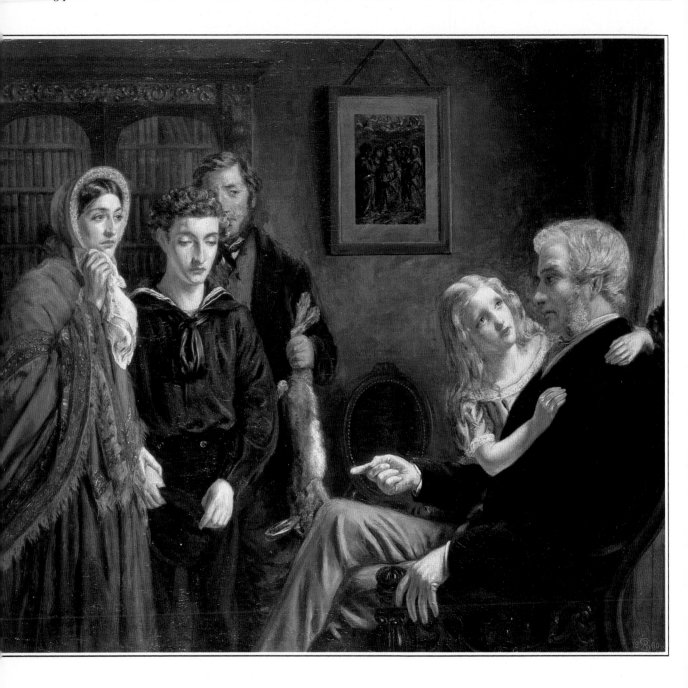

◁ The Plea
Rebecca Solomon (1832-86)

Oil on canvas

THIS ANECDOTE is not hard to
unravel. The sailor boy has been
caught poaching; a gamekeeper
holds the evidence. While the boy's
mother weeps, the squire's golden-
haired daughter pleads with her
father to have mercy on the
handsome lad. The painting is
perhaps of less interest than the
artist. Rebecca Solomon came
from a distinguished London
Jewish family. Taught by her oldest
brother Abraham (1823-62), a
Royal Academy silver medallist
whose early death ended a
promising career, she successfully
exhibited historical and genre
paintings at the Royal Academy
from 1852 to 1869. But by the
latter year her alcoholism had
become an open scandal: she
painted no more and died insane.
More tragic still was the fate of her
younger brother Simeon (1840-
1905), a leading associate of the
Pre-Raphaelites, admired by
Burne-Jones and praised by Walter
Pater. Already an alcoholic, he was
devastated by criminal charges in
1871, became a pavement artist
and died in a workhouse.

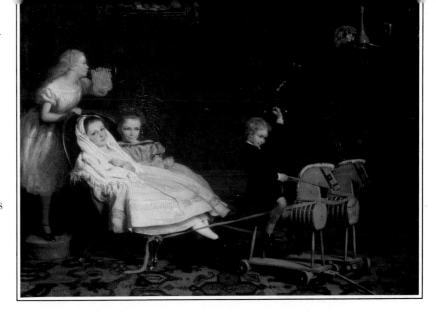

△ A Carriage to the Ball 1840
William Bromley III (fl. 1835-88)

Oil on canvas

A CHARMING STUDY of privileged
children at play by an artist who,
on this evidence, deserves to be
better known. All that can be said
of Bromley is that he was a
London-based painter of historical
and genre scenes and was the
third in an artistic line begun by
the noted engraver (of the Elgin
Marbles, among other
commissions) William Bromley
(1769-1842). The composition is
pleasing, the colouring competent,
the rendering spirited, and the
children refreshingly free of
'cuteness'. A velvet-suited little
brother plays postillion, whipping
up his wooden team so that his
sisters in their armchair coach
shall not be late for the ball. A
third girl takes the role of 'Tiger
Tim' (a generic name for the
liveried servant who would
perform this task in reality),
perched on a step at the rear of
the carriage and blowing a horn
to warn of the approach of the
speeding vehicle.

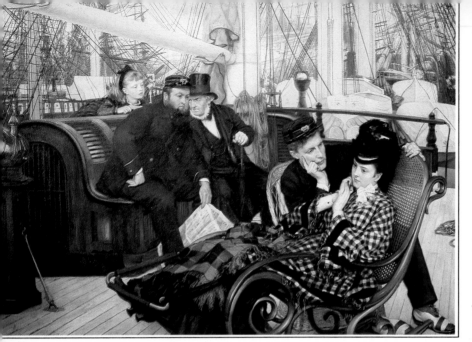

△ **The Last Evening** 1873
James Jacques Joseph Tissot (1836-1902)

Oil on canvas

TISSOT IS ONE OF THOSE Victorian artists whose reputation (and sale-room value) remains high. He specialized in an ever-attractive genre, upper-class life; he was supremely competent; and his photographic realism, especially in the details of women's dress, makes him, like Frith (page 29), a treasure trove for social historians. Forced to flee his native France after taking part in the Paris Commune of 1871-72, he quickly re-established himself as a painter of fashionable life in England. Here we see the finale of a ship-board romance, observed by two disapproving elderly gentlemen and by a rather scornful small girl who fails to see what the fuss is about. There is a romance behind the one pictured: the young man in yachting dress, including ultra-casual two-tone brogues, is the artist himself; the beauty in high-heeled shoes is his mistress, Kathleen Newton. Her death at the age of only 28 changed the nature of his art: most of his later works, including 350 watercolours of the life of Christ, were of religious subjects.

▷ **Cadogan Pier, Chelsea**
George Washington Brownlow
(1835-76)

Oil on canvas

BROWNLOW WAS ONE of many artists and intellectuals who lived in the west London district of Chelsea in the mid-Victorian era. Among his fellow residents then were the painters William Bell Scott (page 24) and Dante Gabriel Rossetti, the humorist Jerome K. Jerome, the philosopher Thomas Carlyle and the novelists George Eliot and George Meredith. Obviously none of them were out and about on the day, some time in the 1860s, that Brownlow captured this slice of Thames-side life. The actors here range from the mother who is treating her second-youngest child to a ride in a goat-cart to the rig's rather bored proprietor and (background, left to right) a businessman in a silk hat, a Chelsea Pensioner in his scarlet overcoat, an apple-woman, and a lounger smoking his pipe beneath a tree. Perhaps it is the child's birthday treat, as the bright attire and toy trumpet seem to suggest. No doubt the mother is pleased to find an attraction that will divert all four children, one in arms and the other three still in dresses.

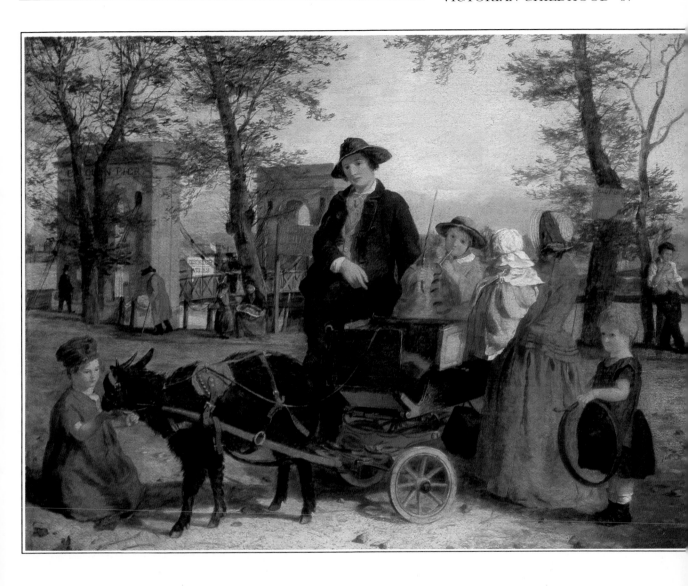

▷ **Playtime**
William Jabez Muckley
(1837-1905)

Oil on canvas

THE WORCESTER-BORN ARTIST
Muckley is known primarily as a
painter of large flower pieces and
of still life, but nothing could be
less tranquil than this violent scene
of children at play. The style is
somewhat archaic, reminding us
of the rococo frolics painted by
Francis Hayman (1707-76); and,
like Hayman, the painting of faces
is obviously not Muckley's strong
suit. However, the boys'
knickerbockers and long woollen
stockings suggest the work dates
from the 1860s-70s. This
'playtime' seems to be getting out
of hand. The boys' flintlock rook-
rifles (of a type obsolescent since
about 1820) look disturbingly
lethal, so no wonder the child on
the right weeps as her doll faces
the firing squad. As the marksman
takes aim, despite the attempt
made by one girl to restrain him
(while her companions look on
smirking), a second boy rams
down a charge of powder and
shot, while a third musketeer
hurries to join in the dangerous
game. Unless an adult arrives
soon, dolly is doomed!

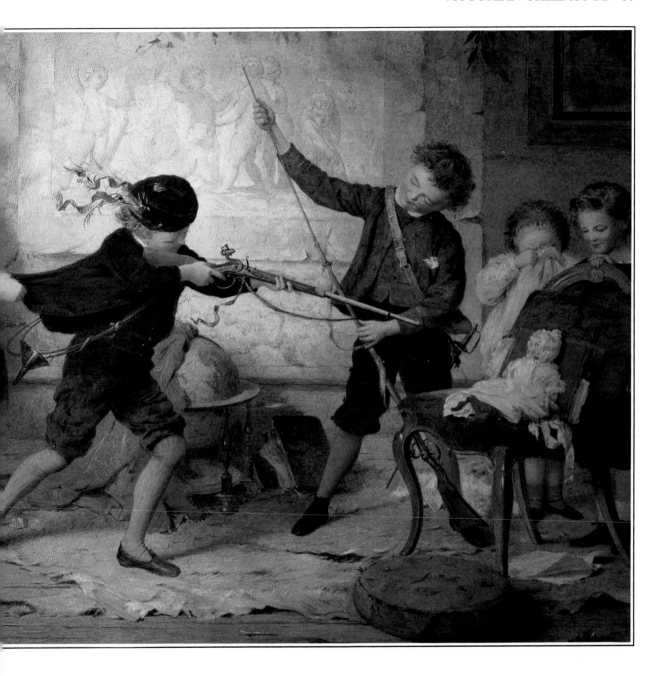

△ **Posy for Grandma**
George Goodwin Kilburne (1839-1924)

Watercolour

IN THE FORM OF A PRINT, this watercolour and many others by Kilburne hung on the walls of many middle-class parlours by the end of the Victorian era and for many years afterwards. The long-lived Kilburne, who exhibited at the Royal Academy and elsewhere for more than half a century, learned his craft during a long apprenticeship to the famous wood-engraving workshop of the Brothers Dalziel but soon abandoned engraving in favour of watercolour. He specialized in scenes showing pretty girls flirting with handsome young men, often in an 18th century or Regency setting, and in more contemporary studies of children, of which the example seen here is typical. The comparatively plain, well-cut walking outfits worn by the mother and daughter appear to date the picture to the later 1880s. Grandma, in her shawl, mob-cap and lace mittens, is the all-purpose elderly party of many a Victorian domestic scene – and seems happy to tolerate having a bunch of prickly-looking flowers thrust almost up her nostrils!

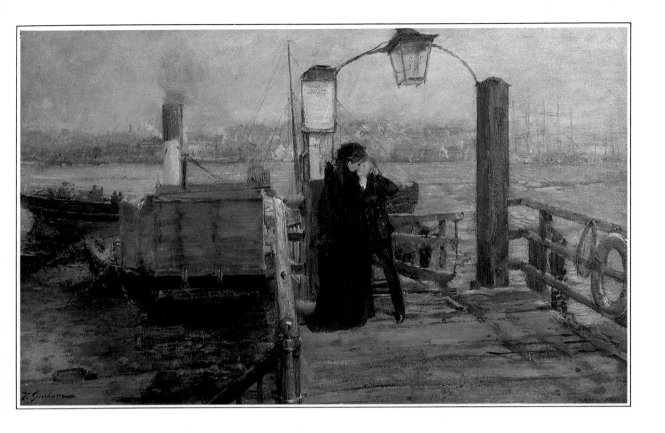

△ **The Landing Stage**

Thomas Alexander Ferguson Graham (1840-1906)

Oil on canvas

GRAHAM'S FINE PAINTING shows a youthful midshipman taking leave of his widowed mother as he prepares to return to duty. The two cling together on the bleak quay, the loneliness that will be the lot of both emphasized by the suggestions of impersonal bustle – the smoking funnel, the crowded launch, the city skyline – in the background. The composition catches the moment so well that it could be a frame from a movie, made all the more effective by its low-key lighting and understated emotion. A naval college, for the son of not-so-wealthy gentry, or a training ship, for the working-class lad who hoped for a naval career, might claim a boy as young as seven or eight in Victorian times, and adolescents saw active service at sea well into the 20th century. Although Graham, an Orcadian born at Kirkwall, exhibited regularly at the Royal Academy, his sensitive art had no great success in an age that preferred sentiment laid on at least with a palette knife, if not a steam shovel.

Detail

▷ **Lost and Found**
William Macduff
(exhibited 1844-76)

Oil on canvas

THE NOVELS OF DICKENS, especially *Oliver Twist* and *Bleak House*, and the work of pioneer sociologist Henry Mayhew, who began his massive survey *London Labour and the London Poor* in 1851, stirred the Victorian conscience regarding London's 'street arabs', the ragged, homeless thousands who begged and stole or starved and died, in the world's wealthiest city. Here, a London-born painter pays tribute to the Tory grandee Anthony Ashley Cooper, seventh Earl of Shaftesbury (1801-85), who curbed the worst excesses of child labour in mines and factories, headed the Ragged School Union that from the 1840s offered at least a little education to the poorest children and furthered Doctor Barnardo's work for the homeless. A boy who, presumably with the aid of charities backed by Shaftesbury, now operates his own shoe-shine stand and is warmly clad, points out the philanthropist's portrait in a print-shop window to a younger lad. 'With his help,' runs Macduff's message, 'we that were lost are now found.'

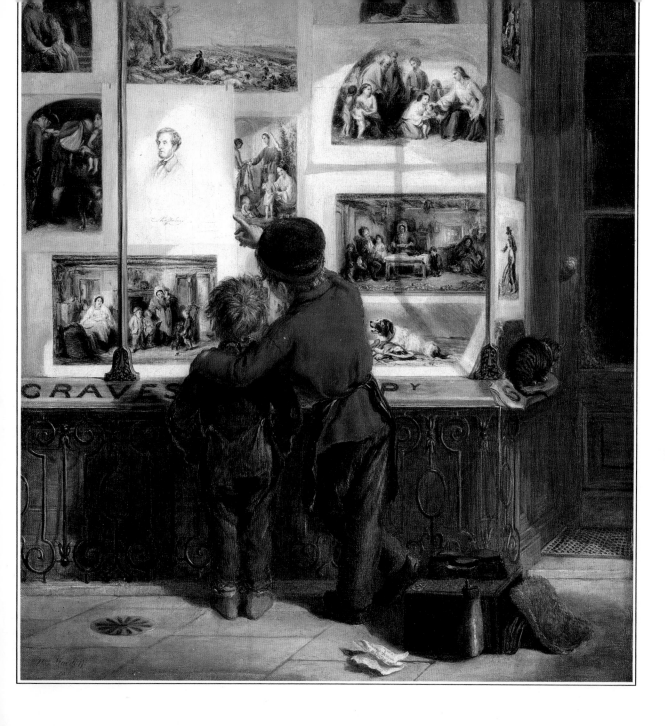

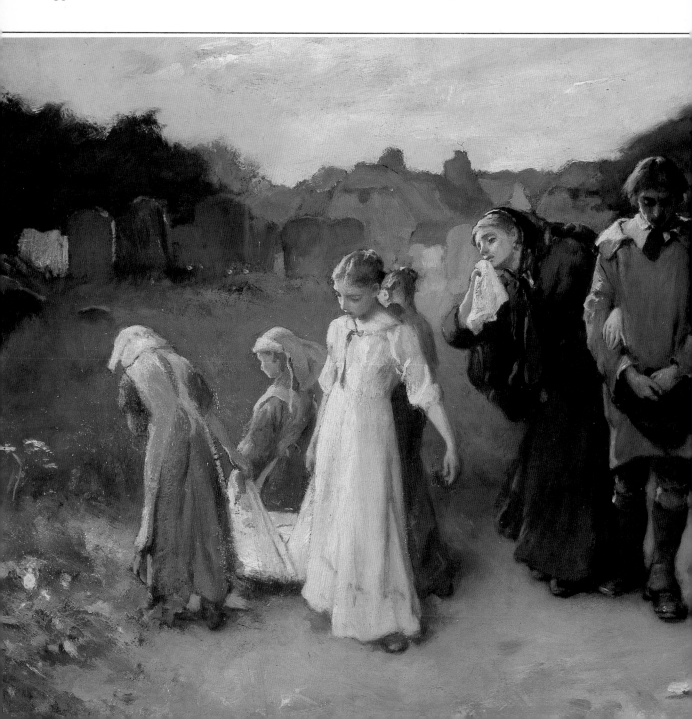

◁ **Her First Born, Horsham Churchyard** 1877
Frank (Francis Montague) Holl (1845-88)

Oil on canvas

IN AN AGE WHEN the trappings of death were ornate hearses, black-plumed horses and and slow-marching mutes (professional mourners), a young couple bury their infant in the simplest possible way. Four village girls, the eldest in her best muslin dress, the others in plain but spotless everyday clothes, carry the tiny coffin to its final resting place. Holl's restrained treatment movingly conveys the way in which grief weighs down all the actors in this rustic tragedy. There is genuine sympathy here and it is probable that the painting's success owes something to the artist's character. Coming from a family of engravers, Holl established himself as a genre painter and then, after 1876, became one of the most fashionable portrait painters of his time, his sitters including the Prince of Wales, Gladstone and Millais. He was deeply religious and, despite working himself to death, found time for charitable activity on behalf of the poor.

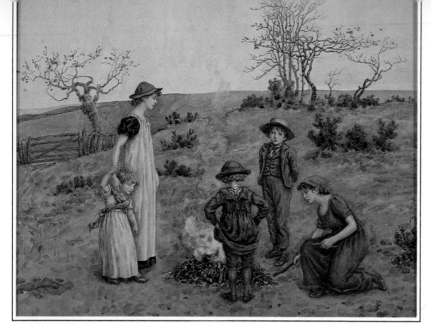

△ **The Stick Fire**
Kate (Catherine) Greenaway (1846-1901)

Drawing

'A LAND OF FLOWERS and gardens... peopled with toddling boys and little girls clad in high-waisted gowns... and frocks of dimity chintz.' Thus John Ruskin, who ranked her among the best artists of the time, described the world created by Kate Greenaway. (Another fan was Paul Gauguin; perhaps impressed by the skill with which she handled flat patterns, a feature of his own work.) In this autumnal scene the charm and delicacy that distinguished her art are immediately apparent – as are the simple, comfortable clothes that

set a fashion for children's dress among aesthetically-inclined Victorians. The daughter of a London wood-engraver, Kate was already a well-established children's author and illustrator when *Under the Window* (1876) became a runaway best-seller in both Britain and the USA. Equally successful were *Kate Greenaway's Birthday Book* (1880), *Mother Goose* (1881) and annual 'Almanacs' in 1883-95. Still much admired, she is commemorated by the Greenaway Medals, awarded annually for the best British children's book illustrations.

▷ **Guarding Baby**
Edwin Frederick Holt
(exhibited 1850-65)

Oil on canvas

BABY TRUSTINGLY CLASPS the paw of her guardian, a large, gentle dog of indeterminate breed which gazes appealingly out at us. The title says all that needs to be said about the painting and the nature of the painting tells us almost all that we need to know about the artist. Holt was one of many Victorian painters who made a decent living by never under-estimating his public's taste for sentimental genre, anecdotal pictures and mythological, historical and biblical scenes. If commissions for paintings flagged, he could turn his hand to illustrations for the many magazines, ranging from the mighty *Illustrated London News* and *Punch* to more ephemeral publications, that offered a market to both writers and artists in those times.

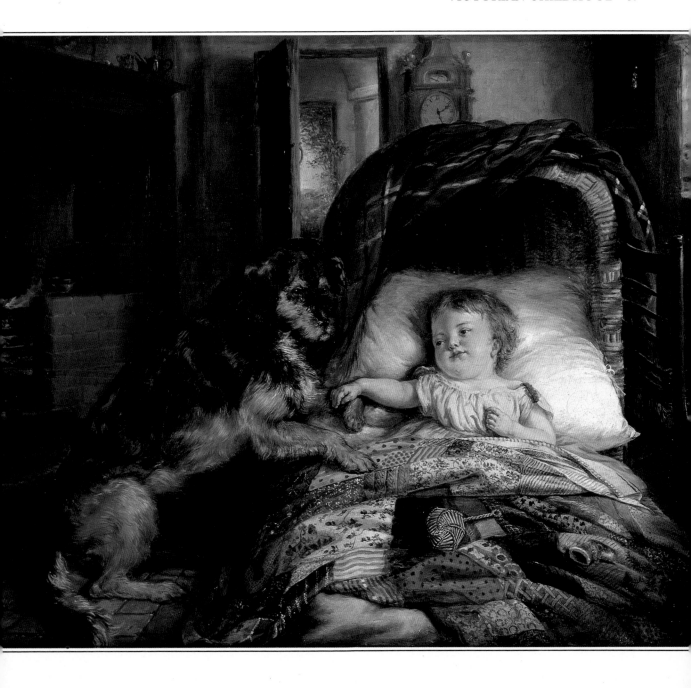

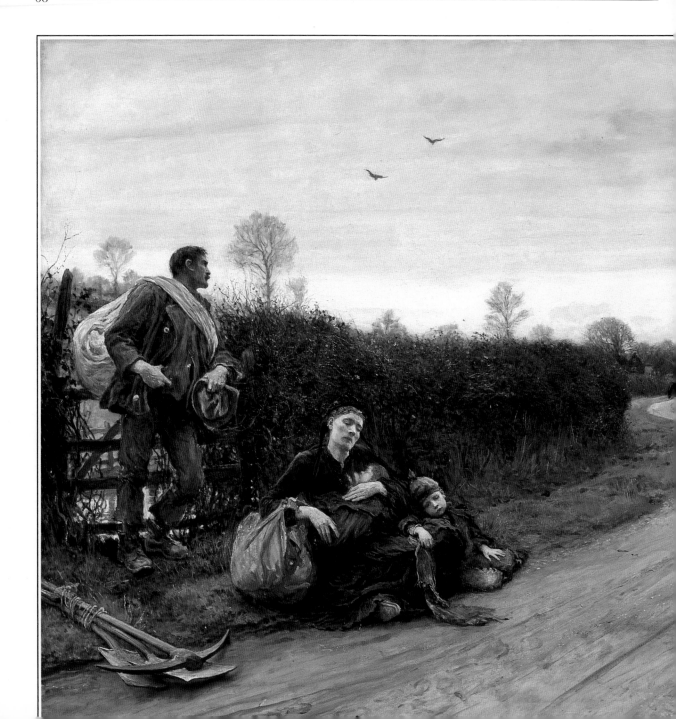

◁ **Hard Times** 1885
Sir Hubert von Herkomer (1849-1914)

Oil on canvas

THE SON OF A BAVARIAN WOODCARVER, Herkomer became a fashionable portrait painter, Slade Professor of Fine Arts at Oxford and, in 1907, a knight. He is now remembered for such 'social documentaries' as *On Strike* (1891) and this painting, a realistic portrayal of a family wandering the roads in search of work. A labourer rests with his tools at his feet, while his wife, a baby at her breast and a small boy sleeping at her knee, slumps by the wayside. The 19th century saw growing unemployment among unskilled men as a result of increasing mechanization and at the time of this painting mass demonstrations by the workless were causing concern. The cinematic quality of Victorian anecdotal painting, already noted, is apparent here: aptly so, for late in life Herkomer became a pioneer of the British film industry, setting up his own movie studio where he produced, directed, designed sets for and even acted in silent films.

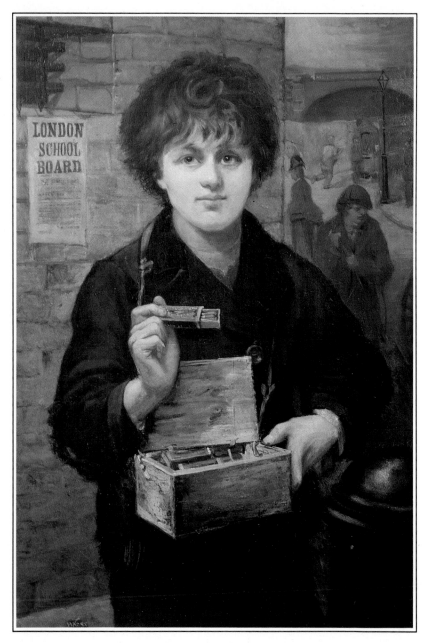

◁ **Match Vendor**
Ernst Hader (exhibited c. 1900)

Oil on canvas

THE PAINTING IS run-of-the-mill Victoriana: a ragged boy – of more appealing aspect, we suspect, than any real-life specimen – hawks 'Lucifers' (as the highly-explosive matches of the time were nicknamed) at a street corner. The important detail is the LONDON SCHOOL BOARD poster at his back. Its message is that such street children now have a chance of bettering themselves through education. Hader's painting dates from some time after 1870, the year of the passing of W.E. Forster's Education Bill and thus of the beginning of modern state education. The Bill authorized School Boards to levy rates in their areas for the construction of elementary schools. Until 1891, when elementary schooling was made free for all, a small fee (as little as one penny per day) was charged for tuition but the poorest parents could apply for a 'free ticket'.

▷ **First Tooth**
Edward Robert Hughes
(1851-1917)

Oil on canvas

THIS PLEASINGLY EXECUTED and
genuinely amusing genre piece
comes from an artist notable for
his connections. Edward Hughes
was the nephew of Arthur
Hughes (1832-1915), one of the
finest Pre-Raphaelite painters,
studied under his uncle and
Holman Hunt, and sometimes
worked as an assistant to the
latter master on his great biblical
works. We may assume that
Hughes was at least acquainted
with Millais and it is surely no
coincidence that the little girl
who is about to get a painful
surprise from the oleaginous
tooth-drawer so closely resembles
the child (the painter's daughter)
in Millais' *First Sermon* (page 46).
The child's features, expression,
hat, hair, and red paletot all
mirror Millais; the mother is
dressed in the style of the 1860s
(although this painting must be
later, considering Hughes' age). It
is permissible to speculate that
Hughes was put up to this parody
by his uncle and Hunt, both of
whom remained true to Pre-
Raphaelite ideals, as a joke at the
expense of the 'apostate' Millais.

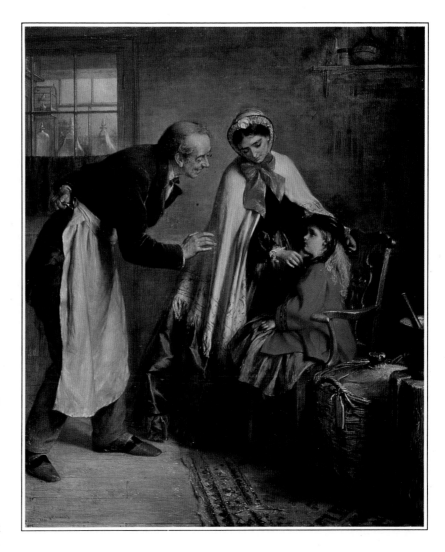

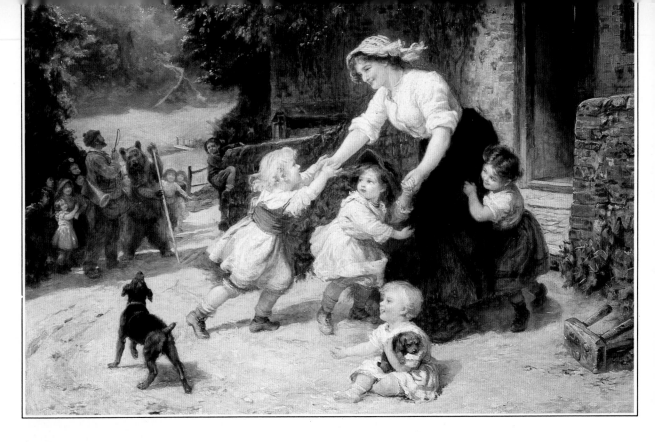

△ **The Dancing Bear**
Frederick Morgan (1856-1927)

Oil on canvas

ALTHOUGH OTHER CHILDREN crowd around to see the bear perform, the youngsters of one family (all save the toddler, who is busy with her puppy) are unsure whether to greet the approaching monster with terror or delight. They run to their mother for reassurance, while the family dog barks defiance. Nothing in the idyllic scene suggests the cruelty used in training performing animals: bears were taught to 'dance' by applying heated metal plates to their feet while music was played. Although most Victorians professed a love of animals (especially dogs, as many of the paintings reproduced in this book testify), few objected to the squalid conditions in which beasts were kept in travelling circuses and menageries. And although the Royal Society for the Prevention of Cruelty to Animals had been founded in 1824, supposedly illegal sports like rat-killing and dog-fighting (favourites of the great animal painter Landseer), cock-fighting and the trap-shooting of live pigeons were widely supported.

▷ **Little Flower Sellers** 1887
Augustus Edward Mulready
(active 1863-1905)

Oil on canvas

THE GRANDSON OF William
Mulready (page 8), Augustus
Mulready followed in his footsteps
as a genre painter and was a
member of the 'Cranbrook
Circle'. Mulready specialized in
works that he hoped would draw
attention to what General William
Booth, founder of the Salvation
Army, called the 'Submerged
Tenth': the estimated (in 1890)
three million Britons living in the
direst want. Although public taste
forbade him to present a scene of
squalor (if he hoped to sell his
work), Mulready's flower girls are
far removed from Shaw's chirpy
'Eliza Dolittle': pale, dressed in
rags, one barefoot, they stand on a
chilly street corner offering their
small posies. On the wall at their
backs are juxtaposed posters
referring to Queen Victoria's
Golden Jubilee of 1877 and to
'The Poor of London'. Mulready
is perhaps hinting that some of the
public money lavished on the
former might have been better
applied to relieving the needs of
the latter.

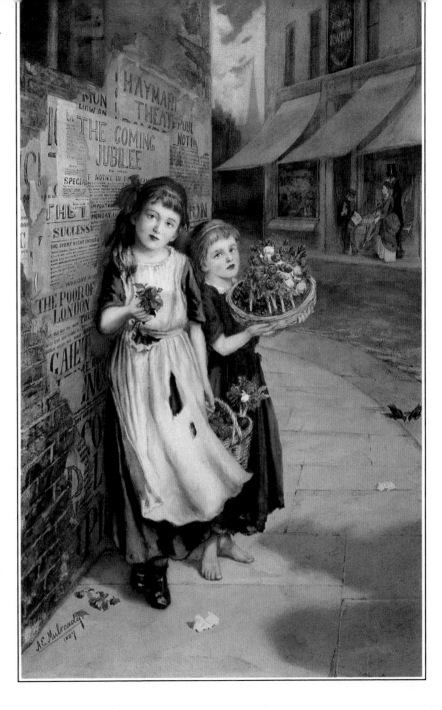

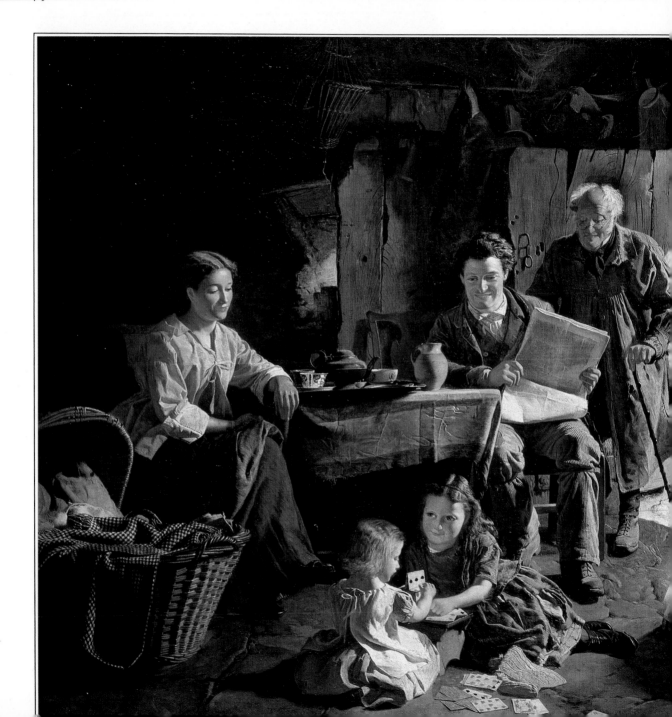

◁ Cottage Interior

William Henry Midwood (active 1867-71)

Oil on canvas

THREE GENERATIONS of happy rustics are depicted in what may be termed the high style of Victorian popular genre, characterized by high finish, improving sentiment and an avoidance of any unpleasant reality. It could be safely said of the little-known Midwood, as it was of Rankley (page 31) by a contemporary, that his paintings of domestic life were 'directed to waken sympathy in favour of that which is kindly in feeling and of good report'. Midwood's cottagers glow with health and wear spotless clothes – although we may wonder why such a flourishing family, with a father who not only is able to read a newspaper but also can afford one, should choose to live in what is apparently a crumbling hovel with a bare stone floor. The artist has borrowed a familiar motif from 17th and 18th century genre masters: the little girls build a house of cards, symbolizing the transitory nature of childhood and innocence.

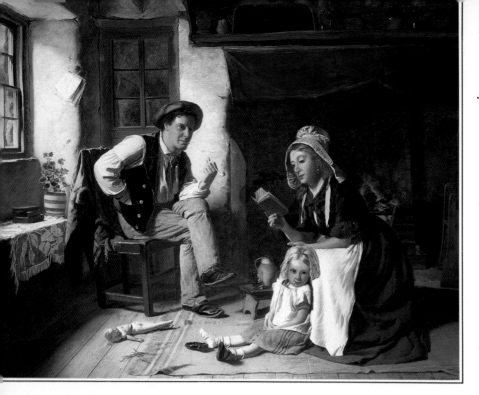

△ **Bedtime Stories**
William Henry Midwood

Oil on canvas

ALTHOUGH THE FATHER is again a labourer – marked down as such, as in *Cottage Interior* (page 75), by the 'yarks', leather straps that secure his corduroys below the knee – this family is obviously more prosperous than Midwood's cottagers. An oak settle stands by the blazing hearth, a rug covers a floor of well-scrubbed boards, and father can afford tobacco for his 'churchwarden' clay pipe, a jug of cider, books, earrings for his wife and a doll for his child. Nor does his little daughter, who does not appear to be paying much attention to her bedtime story, go 'slipshod' in the manner of the poorer working-class child: she wears short woollen stockings beneath her ankle-strapped shoes. Change the costumes, and this could easily be the work of a minor Dutch genre painter of the 17th or 18th centuries.

▷ **The Dole**
John (James) Hodgson Lobley

Oil on canvas

THE ELDERLY POOR of the parish assemble in the village church to receive a dole of bread from the verger. The word 'dole', now associated with state benefits, was used in Victorian times of charitable donations: we can assume that the hand-out seen here was provided for in the will of a wealthy parishioner. Lobley has allowed a discreet amount of realism to enter into his anecdotal work: his rustics, one of whom has brought along her granddaughter to carry the bounty, are a weather-beaten, toil-worn group and one woman sits in an attitude of defeat or despair. He adds social comment in the shape of the cottager's child who turns away to look (with envy, we may think) at the well-dressed girl who leaves the church with her governess. The Huddersfield-born painter Lobley must have had his fill of reality when he became an Official War Artist during World War I, though it is doubtful that he painted that conflict's horrors in the photographic manner seen here.

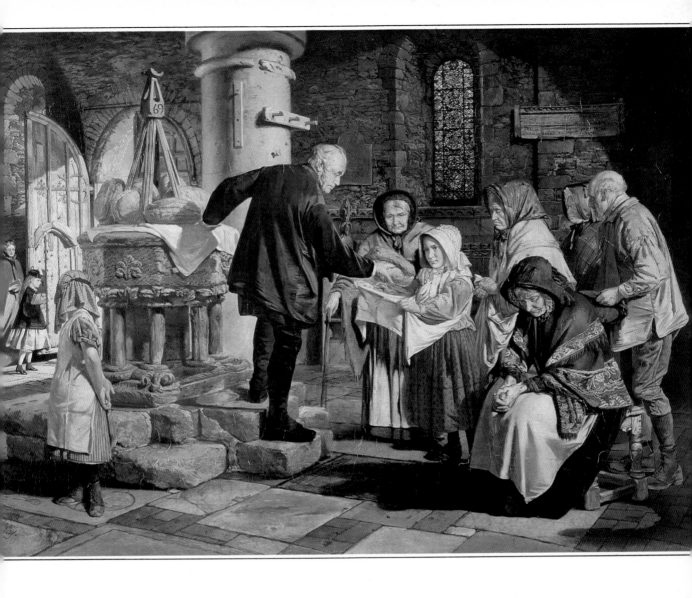

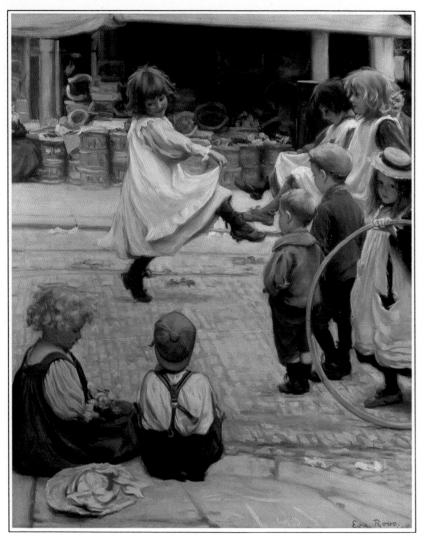

◁ **An Impromptu Ball** 1899
Eva Roos

Oil on canvas

CONTENT SIMPLY TO RECORD, to
let her subject speak for itself
without the aid of sentimental or
unduly picturesque intrusions,
Eva Roos produced this genuinely
charming study of street life at the
very end of the Victorian era.
The little girls in ragged
pinafores, clumsy shoes and
chance-cut hair, dancing perhaps
to the music of an unseen barrel-
organ, are real children, as are
the solemn onlookers. (Note that
the back-to-front cap was a mark
of 'street cred' long before our
time!) We are privileged to see a
moment of happiness in lives that
may otherwise be harsh and drab.
Although born in London, Roos,
a painter and book illustrator
whose work deserves to be better
known, had her training in Paris.
She specialized in studies of
children and, like her husband
the painter S.H. Vedder,
exhibited occasionally at the
Royal Academy around the turn
of the century.

ACKNOWLEDGEMENTS

The publisher would like to thank the following for their kind permission to reproduce the paintings in this book:

Bridgeman Art Library, London/Private Collection: 8, 9, 36-37, 44, 50, 71, 76; /**Victoria & Albert Museum, London**: 10-11, 12-13, 16-17, 20-21, 40-41, 53, 61; /**Bury Art Gallery & Museum, Lancs.**: 14-15; /**Guildhall Art Gallery, Corporation of London**: 18-19, 46 *(also used on front cover, back cover detail and half-title page detail)*, 56; /**Christopher Wood Gallery, London**: 22-23, 30-31, 39, 51, 57, *62*, 63; /**Wallington Hall, Northumberland**: 24; /**Cider House Galleries Ltd., Bletchingley, Surrey**: 25; /**Musée du Petit Palais, Paris/Giraudon**: 26-27; /**Royal Holloway and Bedford New College, Surrey**: 28-29; /**Manchester City Art Galleries**: 32, 68-69; /**Wolverhampton Art Gallery**: 33, 73; /**Metropolitan Museum of Art, New York**: 34-35; /**Forbes Magazine Collection, London**: 38; /**York City Art Gallery**: 42-43; /**Birmingham City Museums and Art Gallery**: 45; /**Elida Gibbs Collection, London**: 47; /**Ackermann and Johnson Ltd., London**: 48-49; /**Pawsey & Payne, London**: 52; /**Geffrye Museum, London**: 54; /**Phillips, The International Fine Art Auctioneers**: 55; /**Albion Fine Art, London**: 58-59; /**Fine-Lines (Fine Art), Warwickshire**: 60; /**Sheffield City Art Galleries**: 64-65; /**Royal Albert Memorial Museum, Exeter**: 66; /**Josef Mensing Gallery, Hamm-Rhynern**: 67; /**Beaton-Brown Fine Paintings, London**: 70; /**Roy Miles Gallery, 29 Bruton Street, London W1**: 72, 74-75; /**Bradford Art Galleries and Museums**: 77; /**Christie's, London**: 78

NB: Numbers shown in italics indicate a picture detail.

Every effort has been made to trace the copyright holders and we apologise in advance for any unintentional omissions. We would be pleased to insert the appropriate acknowledgement in any subsequent edition of this publication.